the **simple secret** to better painting

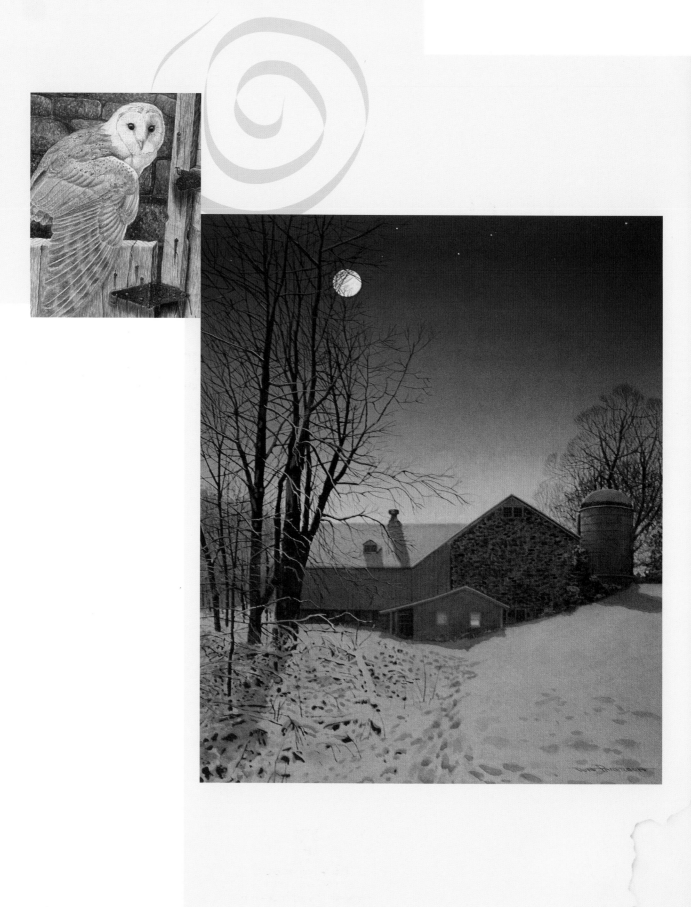

# the
# simple secret
## to better painting

How to immediately improve your work with

the **golden rule of design**

Greg Albert

**NORTH LIGHT BOOKS**
CINCINNATI, OHIO
www.artistsnetwork.com

## about the author

**Greg Albert** is a graduate of the Art Academy of Cincinnati, Ohio, and has advanced degrees in painting and art history.

He is the Editorial Director of North Light Art Instruction Books, and is the author of *Drawing: You Can Do It (1992)*, a North Light instruction book for beginning artists. He has been teaching drawing and painting in the Art Academy of Cincinnati's community education program for over twenty years. He lives in Cincinnati with his wife and daughter.

**The Simple Secret to Better Painting**. Copyright © 2003 by Greg Albert. Manufactured in China. All rights reserved. No part of this book may be reproduced in any form or by any electronic or mechanical means including information storage and retrieval systems without permission in writing from the publisher, except by a reviewer who may quote brief passages in a review. Published by North Light Books, an imprint of F&W Publications, Inc., 4700 East Galbraith Road, Cincinnati, Ohio 45236. (800) 289-0963. First edition.

Other fine North Light Books are available from your local bookstore, art supply store or direct from the publisher.

07  06  05  04  03      5  4  3  2  1

**Library of Congress Cataloging in Publication Data**

Albert, Greg.
    The Simple Secret to Better Painting / Greg Charles Albert.—1st ed.
        p. cm.
    Includes index.
    ISBN 1-58180-256-0 (pbk. : alk. paper)
        1. Painting—Technique. 2. Composition (Art) 3. Color in art. 4. Visual Perception
I. Title.

ND1475 .A53 2003                    2002033786
750.1' 8—dc21                       CIP

Editor: Jennifer Lepore Kardux
Production Editor: Maria Tuttle
Designer: Wendy Dunning
Layout Artist: Karla Baker
Production Coordinator: Mark Griffin

## metric conversion chart

| to convert | to | multiply by |
| --- | --- | --- |
| Inches | Centimeters | 2.54 |
| Centimeters | Inches | 0.4 |
| Feet | Centimeters | 30.5 |
| Centimeters | Feet | 0.03 |
| Yards | Meters | 0.9 |
| Meters | Yards | 1.1 |
| Sq. Inches | Sq. Centimeters | 6.45 |
| Sq. Centimeters | Sq. Inches | 0.16 |
| Sq. Feet | Sq. Meters | 0.09 |
| Sq. Meters | Sq. Feet | 10.8 |
| Sq. Yards | Sq. Meters | 0.8 |
| Sq. Meters | Sq. Yards | 1.2 |
| Pounds | Kilograms | 0.45 |
| Kilograms | Pounds | 2.2 |
| Ounces | Grams | 28.3 |
| Grams | Ounces | 0.035 |

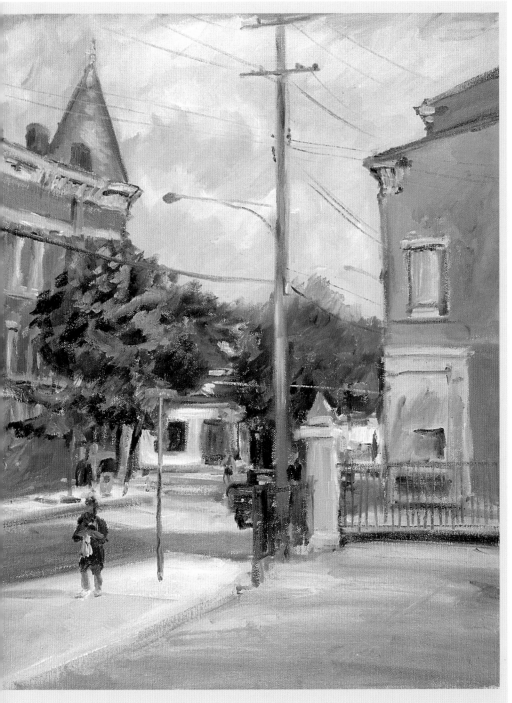

**Corner of Chase and Hamilton** ❊ Greg Albert ❊ 20" x 16" (51cm x 41cm) ❊ Oil on canvas

## dedication

This book is dedicated to my wife, my daughter and my mother: **Mary Beth** for her unending patience and support, **Elizabeth** for her spirit and **Mom** for her prayers.

## acknowledgments

My years editing have taught me that every book is a team effort, not the product of one individual. This book could not have happened without the help of the following people, to whom I extend my deepest gratitude: **Jennifer Lepore Kardux** for her patient and firm direction; **Rachel Wolf** for her wise counsel from the very beginning; **Wendy Dunning** for her wonderful design work; and to **all the contributing artists** whose work graces the pages of this book.

Most of the ideas in this book are not my original creation, although I hope their synthesis into my concept of the one rule of composition makes them more accessible to painters. I was informed and inspired by many sources, in particular the watercolor instruction books by "the two Tonys," **Tony Couch** and **Tony Van Hasselt**, who have made many lessons for painters clear and memorable.

# table of
# contents

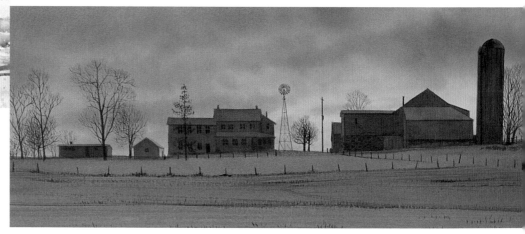

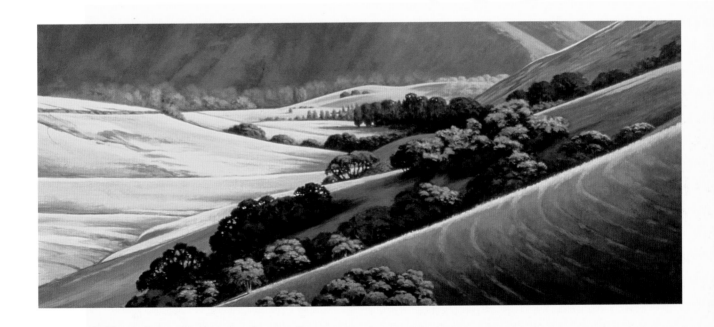

# introduction

How often do you look at your just-completed painting or drawing and have the nagging feeling it just isn't right? That the picture is not as satisfying as it should or could be? And that you can't quite figure out what would make it better?

You look at your painting and study it. The proportions are right, the perspective is fine and the colors match what you see. Still, something makes the painting look a bit wrong. It doesn't look balanced, or something about the arrangement of the shapes is distracting. It just doesn't "work." You're at a loss as to what is exactly wrong or what to do about it.

This book will not only give you a tool to identify what is wrong with a painting that isn't quite right and what to do to make it better, but it will give you a simple tool to make better paintings from the start. The secret is in designing the painting so it is a great composition.

Like Goldilocks, we want to create a composition with shapes, colors, textures and other elements that are not too dull, not too distressing, but "just right."

**The secret for designing great compositions**

Much has been said about how to design great pictures. Whole books have been written about the art or even science of pictorial composition. Some of it is surprisingly complicated, using the geometry of the ancient Greeks as its base.

But much of what has been said about composition is utterly useless when you're standing in front of a blank canvas. All the formulas and theories don't help you then. In fact, they can just make you more confused and bewildered, adding frustration to an already daunting challenge.

Applied consistently, one rule of composition will eliminate all the most subtle design flaws. The **ONE RULE** is:

*Never make any two intervals the same*

Intervals that are the same are boring. Intervals that vary are interesting. In this book, you will learn how this rule can be applied not only to intervals of distance, but also to shape, tonal value, color and just about every other element in your painting.

You will be surprised how often the **ONE RULE OF COMPOSITION** can be used and how easy it is to remember. You can use it when you begin painting to avoid mistakes from the start. You can use it when you are in the midst of painting to make the right decisions about color and value. You can use it when you're done painting to analyze the picture to determine how it could be improved. You can also use it to critique any painting to learn how you could have made the picture better.

This book is designed to be read quickly and remembered forever. Once you see how this one rule of composition is so far-reaching and effective, you will find yourself applying it automatically. You'll wonder how you ever made a well-composed painting on purpose without it.

So, with an open mind, let's begin.

**Near Knowlton's Corner** ✳ Greg Albert ✳ 16" x 20" (41cm x 51cm) ✳ Oil on canvas

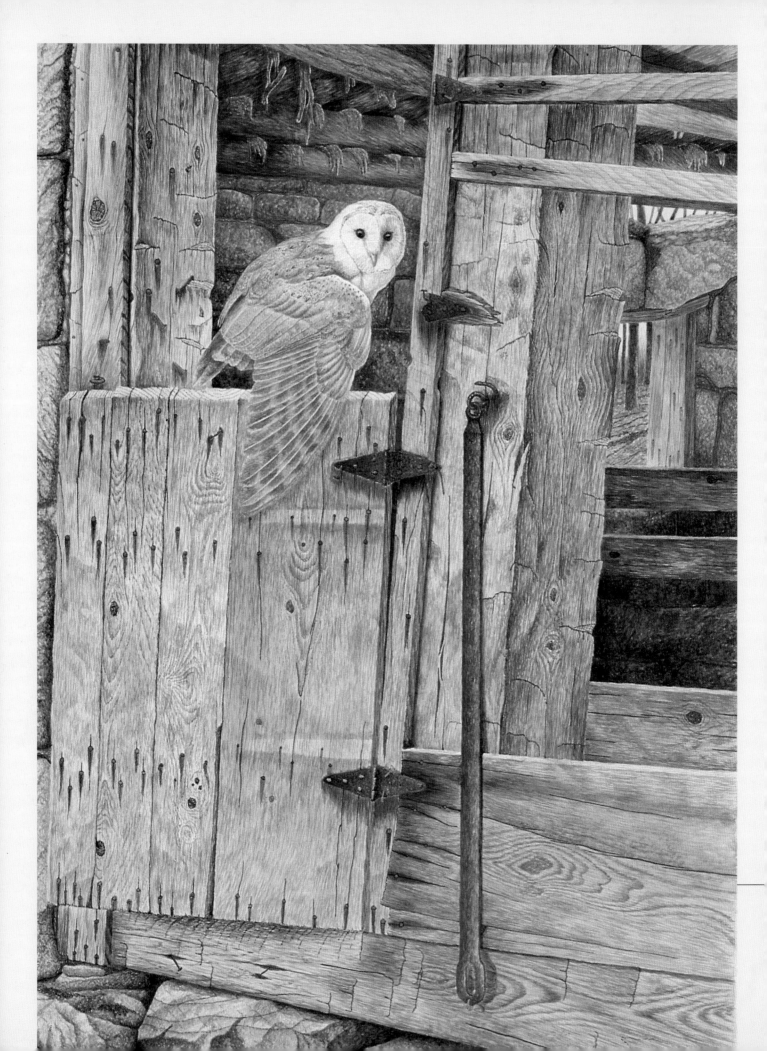

# design
## dynamics

**Never make any two intervals the same.**

## Why?

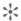

Simply put, we crave variety and abhor monotony. We humans get bored

pretty quickly. We get tired of the same old thing in a very short time, be it

what we eat, hear, feel or see. Think how tiresome eating the same foods at

every meal would be. It is in our nature to seek change, to introduce variety in

our lives. Good composition is based on this fact of human nature. Just as

we find an unchanging diet unappetizing, we find unchanging pictorial ele-

ments uninteresting.

In this chapter, we will explore why the **ONE RULE OF COMPOSITION**

works and why it is the foundation for the remaining chapters in this book.

● **Barn Owl** ☀ Tom Gallovich ☀ 30" x 22" (76cm x 56cm) ☀ Watercolor on paper

# design a preference test

Let's start our exploration of design and composition with a look at how we respond to certain visual stimuli. Complete the following exercise. It is in no way scientific, but no less revealing. It is not a test of your aesthetic sense, your personality or your worth as a human being. It's just a good way to start thinking about how we respond to pictures.

*Below* are five pairs of designs. Look at each pair and mark which one either attracts your attention or appears more dynamic and interesting. Go with your first impulse. Pick the one you like more or think is better for whatever reason. You can't make a wrong choice. Do it now before reading on.

**Which designs do you find more interesting?**
In this exercise, each pair has one design that has more complexity created by differing intervals of dimension, spacing, distance or some other characteristic. The other design has less varied intervals, producing less complexity. Go back now and see which one of each pair you chose to be more interesting or dynamic: the one with greater variety of intervals or the one without.

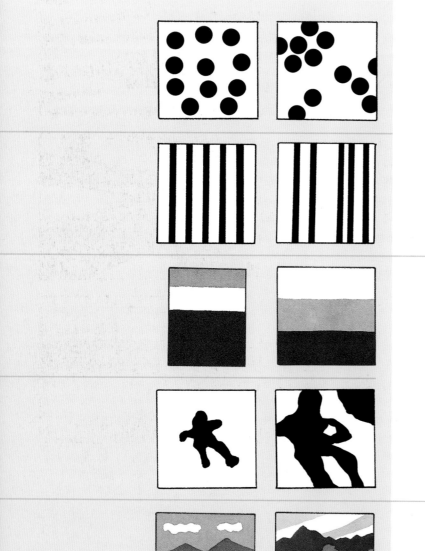

# play with design

Let's do another exercise that is more of a game than a test like the one on the *facing page*. In this exercise, look at the ten black-and-white designs *below*, labeled A through J. After looking at all of them, answer the questions at the right. As in the previous exercise go with your first impulse. Use your imagination here. There are no right or wrong answers. You will most likely pick different answers than someone else, but neither of you would be wrong. You might also select the same design for several of these questions.

## design decisions

→ Which design would you select to be the *most active*?
→ Which design would you select to be the *most inactive*?
→ Which design would you select to be the *fastest*?
→ Which design would you select to be the *slowest*?
→ Which design would you select to be the *heaviest*?
→ Which design would you select to be the *lightest*?
→ Which design would you select to be the *loudest*?
→ Which design would you select to be the *most quiet*?
→ Which design would you select to be the *most boring*?
→ Which design would you select to be the *most interesting*?

# another design game

Now, let's be a little more playful and imaginative with your choices. From the ten designs *below*, pick the one that you feel best answers the questions at the right. Again, there are no right or wrong answers. Don't think about this too much. Go with an impulsive choice.

You can play this game for a long time. Try it with different people. After they make their selection, ask them why they picked what they did. Try it with a group—it's an interesting party game.

## design decisions

→ Which design would you select to be the *happiest*?

→ Which design would you select to be the *saddest*?

→ Which design would you select to be *laughing out loud*?

→ Which design would you select to be a *shrill scream*?

→ Which design would you select to be *relaxed*?

→ Which design would you select to be *tense and nervous*?

→ Which design would you associate with the taste of a *vanilla ice cream*?

→ Which design would you associate with the taste of *tart cherries*?

→ Which design would you associate with *a bad headache*?

→ Which design would you associate with *a thunderstorm*?

Here are a few more associations that will stretch your imagination:

→ Which design suggests flight? Monday morning? A tax audit? Sauerkraut? Groucho Marx? High anxiety?

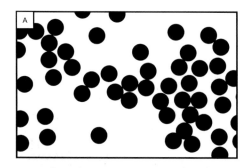

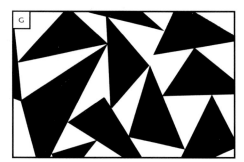

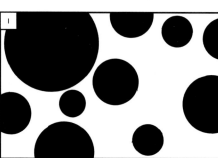

# visual tension

As we discovered with the previous games, we naturally associate various characteristics with abstract designs. Imagine arranging these designs in an order such as slowest to fastest, relaxed to nervous, lightest to heaviest or even sweet to sour.

Some designs will gravitate toward the slower, quieter, heavier side of these orderings, and others will be toward the faster, louder, lighter side. We could also arrange any designs in a scale with the most boring, predictable, dull design on one end and the most chaotic, busy, unpleasant on the other, as *shown below*.

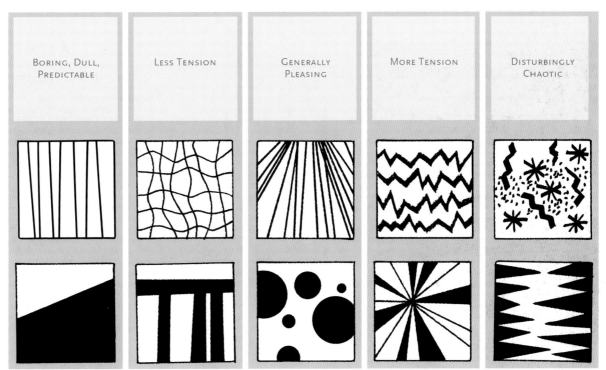

**Dull-to-distressing designs**

This scale measures the amount of *visual tension* in a design. Here are two series of designs arranged in a scale or spectrum of visual tension. The dullest and most boring designs are on the left. These designs are orderly and predictable and are the least interesting. The most distressing and chaotic designs are on the right. These designs are so irregular and busy that they are unpleasant to look at. On either extreme, the designs are not appealing.

Somewhere in the middle of the dull-to-distressing scale of visual tension are the designs that are generally pleasing. They are stimulating to the brain without being overwhelming.

# visual energy

We are all unique individuals with different experiences, beliefs and associations, and no two people will read the same associations or interpretations into the marks that we make. The design games on the *previous pages* show that people will have different responses to the same configurations. However, as distinct as we are one from each other, we also share much in common. There are some generalizations about the designs on the *previous pages* that are sufficiently broad to be useful to the artist.

One concept we can use to discuss the reactions most people have to certain marks is that of *visual energy*. Some marks and patterns are seen as having more energy than others, appearing to be more active or even in motion.

Horizontal lines appear less energized than vertical, vertical less than diagonal. As order decreases, energy appears to increase.

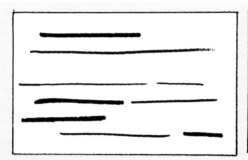

**Passive**
Horizontal lines exhibit little energy. They appear passive.

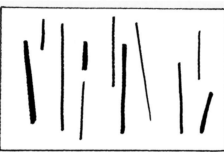

**Active**
Vertical lines exhibit more energy because they resist gravity.

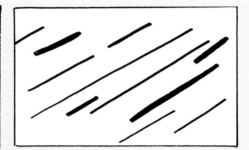

**Energetic**
Diagonal lines are even more energetic because they actively fight gravity.

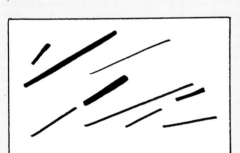

**Motion**
These lines suggest energy in motion.

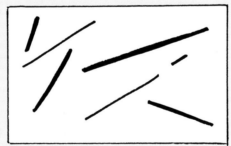

**Uncontrolled motion**
These lines suggest uncontrolled motion, perhaps falling.

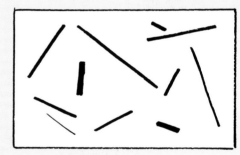

**Explosive motion**
These lines suggest almost explosive energy.

# visual weight

Another concept that we can use to describe certain marks is that of *visual weight*. Just as some designs appear more active, some appear to be heavier. They have an apparent weight or heft that suggests they are more massive, ponderous or inert than others. Other designs just seem to be less heavy, capable of floating or being easily lifted or set into motion.

Often, but not necessarily always, weight and energy are exclusive. Many designs with more apparent visual energy do not have a quality of weightiness, and inactive designs do not have a quality of lightness.

Nevertheless, the terms *visual energy* and *visual weight* are useful—if not exactly scientific—ways to discuss the impression certain designs, marks or patterns have on most people.

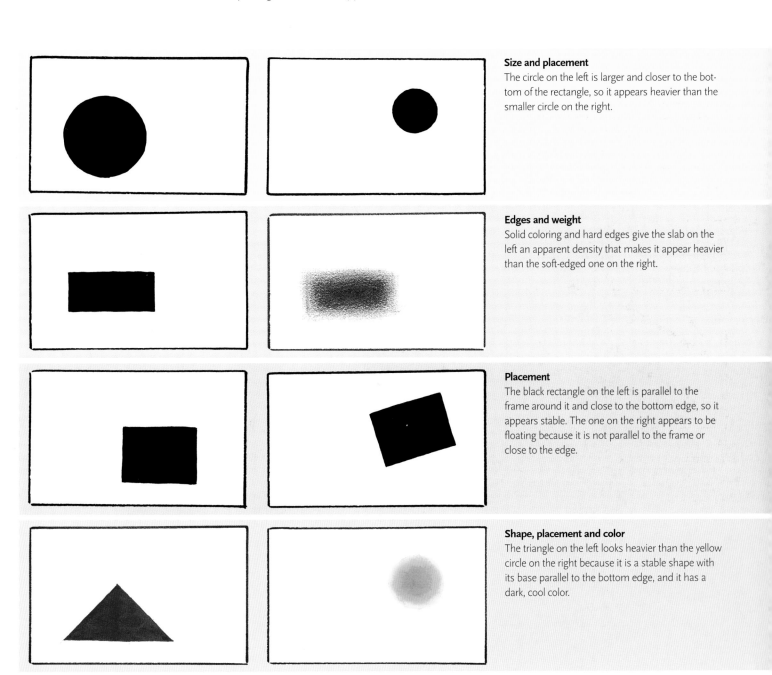

**Size and placement**
The circle on the left is larger and closer to the bottom of the rectangle, so it appears heavier than the smaller circle on the right.

**Edges and weight**
Solid coloring and hard edges give the slab on the left an apparent density that makes it appear heavier than the soft-edged one on the right.

**Placement**
The black rectangle on the left is parallel to the frame around it and close to the bottom edge, so it appears stable. The one on the right appears to be floating because it is not parallel to the frame or close to the edge.

**Shape, placement and color**
The triangle on the left looks heavier than the yellow circle on the right because it is a stable shape with its base parallel to the bottom edge, and it has a dark, cool color.

# dynamics of the frame

Any mark, shape or pattern on a surface creates a relationship with the edges of that surface, be it a piece of drawing paper, a pad of watercolor paper, a canvas or any other surface we can decorate or embellish. The mark interacts with the edges of the surface, creating a dynamic relationship that is affected by our sense of visual tension, weight or energy as discussed earlier.

Since most painting and drawing are done on a rectangular surface, the dynamics of that format are an important part of composition.

Movement, thrust and conflict can be suggested by a mark's orientation and proximity to the edges of its rectangular frame. In the examples on this page, position, distance, weight and energy affect our interpretation.

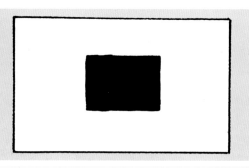 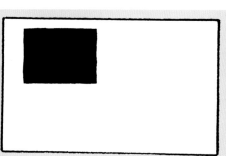

### Distance from the frame
The closer a figure is placed to the edge or boundary of the rectangular frame, the greater the visual tension produced. The shape on the right has greater visual energy and less weight than the one on the left because it appears to be approaching, or perhaps trapped by, the corner of the frame.

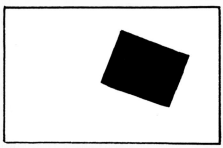 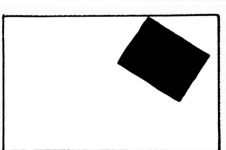

### Orientation within the frame
Both of these shapes have greater energy than the ones above because they have an oblique orientation. The shape on the right produces greater visual tension because one corner impinges on the frame. Its sharp corner is in contact with the edge and creates several angular shapes.

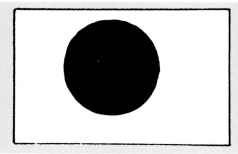 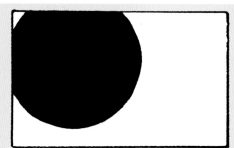

### Movement through the frame
The black circle on the right generates greater visual tension or energy because it appears to have broken through the frame. Visual tension is created by the ambiguity of its movement either in or out of the frame and by its large size relative to that of the rectangular frame.

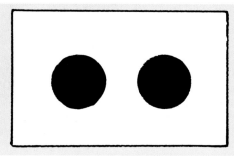 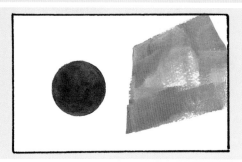

### Relationships within the frame
The two circles on the left have a static relationship with the frame: they are equidistant from the edges and from each other and therefore exhibit little visual tension or energy. On the right, the circle contrasts with the shape next to it. They vary in size, color, shape, texture, orientation and contact with the edges of the frame, generating much more visual tension.

# why the ONE RULE OF COMPOSITION works

The rule *Never make any two intervals the same* is based on human nature. We seek change to add variety in our lives. By varying the intervals as we compose our paintings, we introduce variety. Successful composition is based on this human need.

This book focuses on how to make a pleasing design, because that is what most artists want most of the time. However, all the rules for making a design pleasing also can be used to make an unpleasant design—either unpleasantly boring or unpleasantly chaotic—if that is your artistic intention.

Since we are all unique individuals with different experiences, beliefs and associations, no two people will read the same message into the marks that we make. The marks we make are open to unlimited interpretation; they are symbols with no exact, universal meaning.

## the science behind a good composition

The rule *Never make any two intervals the same* may even have a physiological basis. When a nerve is stimulated, a complex chemical reaction takes place that sends messages to the brain. If the stimulus is repeated or is of long duration, the nerve depletes itself of certain chemicals and can no longer send messages to the brain. The sensation ceases and we say the nerve has gone numb. In short, repetitive stimuli deaden the nerves. To prevent numbing over-stimulation, we need a variety of stimuli that excite but don't deaden our brains.

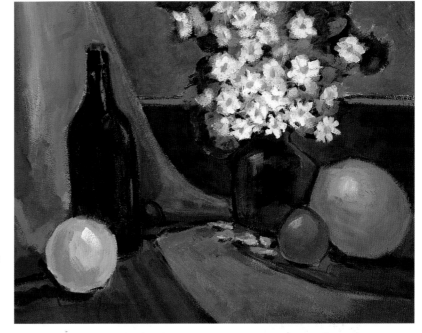

**Create interest with variety**
This painting is a quick study in the conscious, deliberate application of the **ONE RULE OF COMPOSITION:** *Never make any two intervals the same* to an imaginary still life. All the dimensions were intentionally made different. There is enough variety to create interest, but not so much as to disrupt the overall unity of the picture. (The compositional principles applied here will be examined in detail in the following chapters.)

**Vary the shapes**
The shapes of the objects vary in size and complexity (although in retrospect, it appears that there may be too many boring circular shapes—perhaps a lemon and a pumpkin could have replaced the generic yellow and orange shapes).

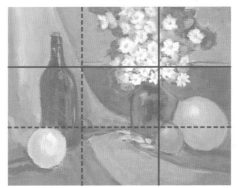

**Concentrate on placement**
The center of interest—the flowers—is located at the intersection of vertical and horizontal thirds. The flowers form a focal point (an eye magnet) because they are the lightest, brightest objects, have greater detail and complexity, and are visually more active than other parts of the picture.

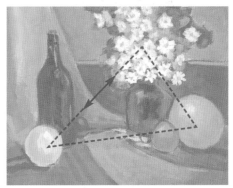

**Lead the eye**
The lines lead the eye into the picture, not out. Any lines or shapes that might direct the viewer's attention to an outside edge or corner of the picture have been avoided.

The three lightest focal areas, the flowers, the yellow shape and the orange shape, form three points of interest that keep the eye circulating within the rectangle. Notice too, how they form a triangular path, no side of which is parallel to the frame.

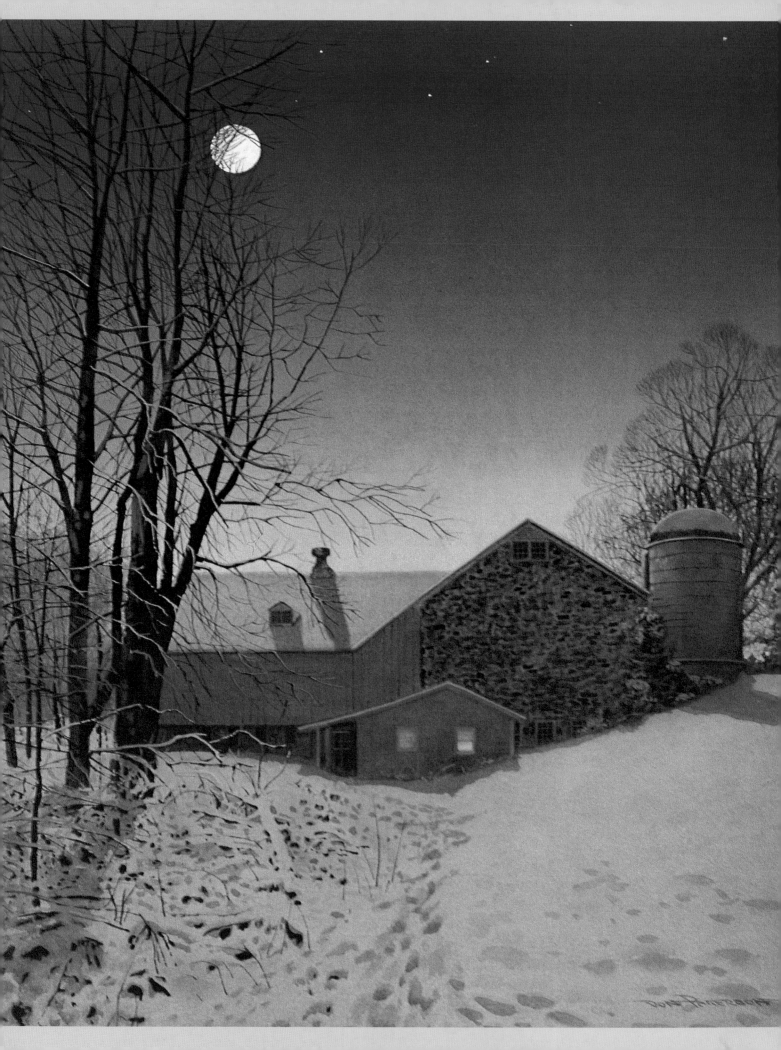

# *making things* interesting

In the *previous chapter*, we learned that visual arrangements are inherently expressive. Due to our natural impulse to give meaning to things in our environment, all designs evoke an emotional response. But not all of these arrangements are aesthetically pleasing. Some visual arrangements are more interesting than others, or are more pleasurable to look at.

**What makes things visually interesting?**

In a word, **variation**.

By following the **ONE RULE OF COMPOSITION**: *Never make any two intervals the same* you introduce the variety needed to make your pictures interesting and pleasing. By varying the intervals between the divisions of your painting, by varying the intervals between the objects depicted, by varying the dimensions of the shapes you make, and by varying the placement of things shown, you make your painting more appealing to the eye.

In this chapter, we will look at how applying the **ONE RULE OF COMPOSITION** to as many aspects of your painting as possible will make your work visually interesting and almost guarantee that your compositions will be successful.

● **Full Moon** ✳ Donald W. Patterson ✳ 18" x 15" (46cm x 38cm) ✳ Watercolor and gouache on paper

# dividing the boundaries of your painting

The edge or frame of a visual image creates the illusion of space within that boundary. Even a blank canvas suggests space, albeit undefined in any way. Draw a line or any mark on that blank canvas and the pictorial space within the frame is more defined. Draw a line across a rectangle and the line could be the sea meeting the sky, an edge of a table, the bottom of a wall or window.

How you divide the rectangle should follow the **ONE RULE OF COMPOSITION:** *Never make any two intervals the same.*

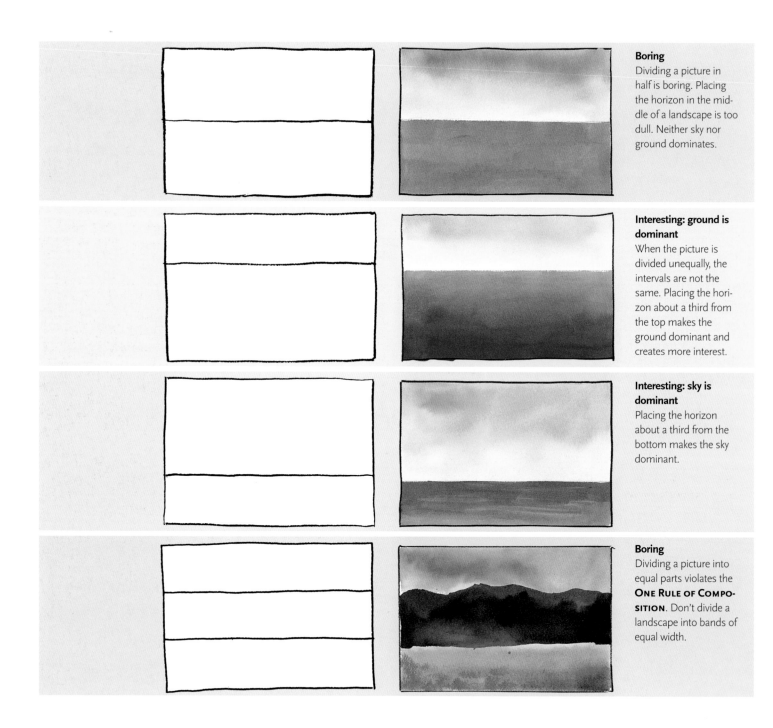

**Boring**
Dividing a picture in half is boring. Placing the horizon in the middle of a landscape is too dull. Neither sky nor ground dominates.

**Interesting: ground is dominant**
When the picture is divided unequally, the intervals are not the same. Placing the horizon about a third from the top makes the ground dominant and creates more interest.

**Interesting: sky is dominant**
Placing the horizon about a third from the bottom makes the sky dominant.

**Boring**
Dividing a picture into equal parts violates the **ONE RULE OF COMPOSITION.** Don't divide a landscape into bands of equal width.

## Enhance visual interest

Almost any equal division of your picture will be boring; for example, dividing a picture with a line that goes from corner to corner on the diagonal. Although one side is not the mirror image of the other, it still creates regular intervals and is therefore boring. Any division of space is an opportunity to enhance visual interest.

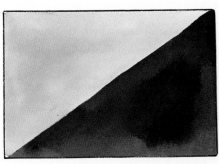

**Boring**
Don't divide a picture into equal halves, as does a diagonal from corner to corner.

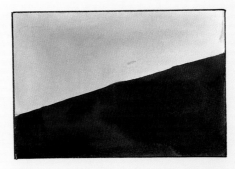

**Better**
Although not corner to corner, this oblique divides the picture into equal halves. The line divides each side into lengths of the same proportion.

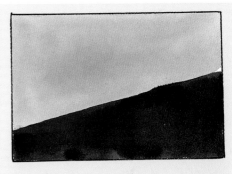

**Best**
This oblique divides the rectangle into unequal portions. The distance from the top to the line on the right is not equal to the distance from the bottom to the line on the left.

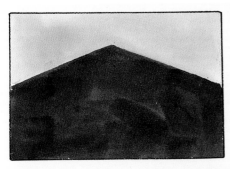

**Boring**
Placing a mountain peak in the exact center with sides of equal length violates the **ONE RULE OF COMPOSITION:** *Never make any two intervals the same.*

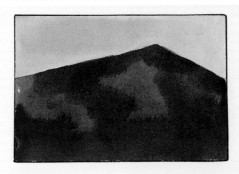

**Better**
Placing the peak off-center makes it more interesting. However, the sides of the rectangle are divided into the same intervals.

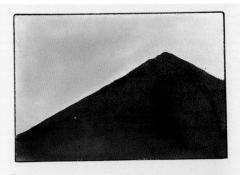

**Best**
In this arrangement, no two intervals are the same. The sides of the mountain are different lengths, the peak is off-center, and the sides of the rectangles are divided into four different lengths.

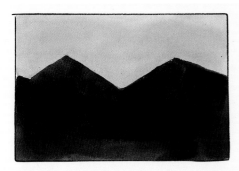

**Boring**
The sides and angles are equal and they divide the rectangle in half in this example. It is monotonous and boring.

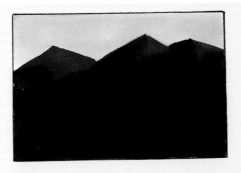

**Better**
This mountain skyline is nearly as boring because the peaks are spaced equally, are of the same angle, and have sides of the same length.

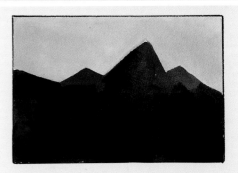

**Best**
This skyline is more interesting because the angles and the lengths of the sides are varied.

# interesting boundary divisions

The paintings on this page are good examples of interesting divisions of a rectangle. These landscapes are divided into unequal intervals by the horizon line and other horizontal lines. Applying the **One Rule**: *Never make any two intervals the same* by placing major divisions of your picture at unequal distances is an effective way of making your pictures more interesting.

**High horizon line**
The horizon line is high in this painting, increasing the drama of the farm buildings silhouetted against the sky.

**Last Glow**  ✳  Donald W. Patterson  ✳  13" x 20" (33cm x 51cm)  ✳  Watercolor and gouache on paper

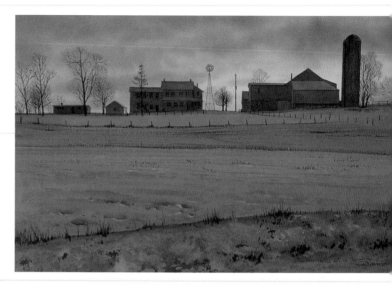

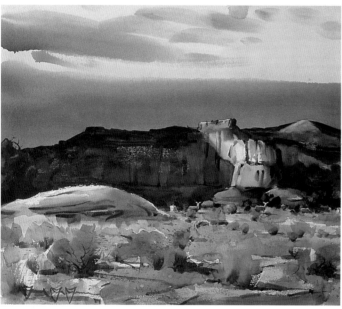

**Multiple horizon bands**
This composition is divided into several horizontal bands of varying widths echoing the strata of the canyon walls.

**Canyon Lands**  ✳  Frank LaLumia  ✳  20" x 24" (51cm x 61cm)  ✳ Watercolor on paper

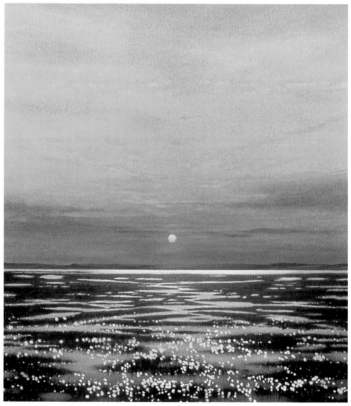

**Low horizon line**
The horizon line is low in this painting, making the sky dominant. The sun is equidistant from the sides, a relatively inactive placement, that is appropriate for the calm sunset depicted.

**Estuary Light**  ✳  Robert Reynolds  ✳  24" x 20" (51cm x 61cm)  ✳ Watercolor on paper

# dividing the space between objects

Let's look at how the *intervals* or spaces between objects makes the objects more attractive to the eye. How things are arranged relative to each other determines the degree of interest generated for the viewer.

In the examples on this page, the spacing is increasingly irregular. The visual interest increases with added variation.

**Boring**
Even spacing is the least interesting arrangement.

**Better**
Adding some variation to the spacing adds interest, but there is still a regular pattern.

**Best**
No intervals are the same, slowing the eye's ability to detect a pattern when scanning.

**Vary width**
Varying the width of the lines adds more variety and interest.

**Vary orientation**
Varying the orientation disrupts the monotonous parallel arrangement and increases interest.

**Vary all the intervals**
Varying the intervals between the lines, their alignments and their widths generates much more visual activity.

# varied spacing adds interest

This page shows a sequence of panels which illustrates how spacing and detailing adds interest to a row of trees. Notice how boring and contrived the regularly spaced row of pine trees appears when compared to the much more natural-looking arrangement of trees in the other panels. The rule at work here applies to other objects as well. A row of evenly-spaced wine bottles in a still life would be dull, too.

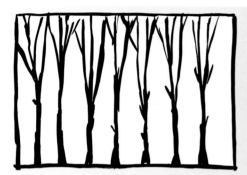

**Boring**
Avoid the repetitive spacing of elements.

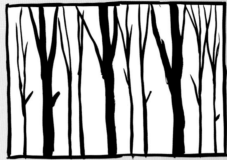

**Better**
A repeating pattern of varied intervals is more interesting, but still predictable.

**Best**
The more varied the spacing and thickness of trunks is, the more natural and interesting the pattern.

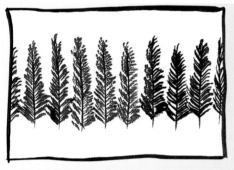

**Boring**
This spacing is artificial.

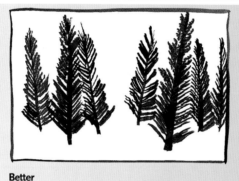

**Better**
By varying intervals of distance, length and angle, interesting variety is introduced.

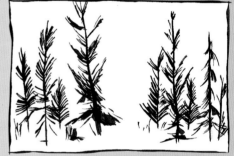

**Best**
This spacing is much more interesting than the previous examples. It looks natural.

# creating interesting shapes

Every shape in your paintings should be an interesting shape. In general, complex shapes are more interesting than simple shapes; a shape with varying dimensions is more interesting than one without. A shape with an oblique diagonal thrust is more interesting and dynamic than one that parallels the edges of the surrounding frame. A shape with projections and indentations is more interesting than one that is convex. The more a shape complies with the **One Rule**: *Never make any two intervals the same* the more interesting it becomes.

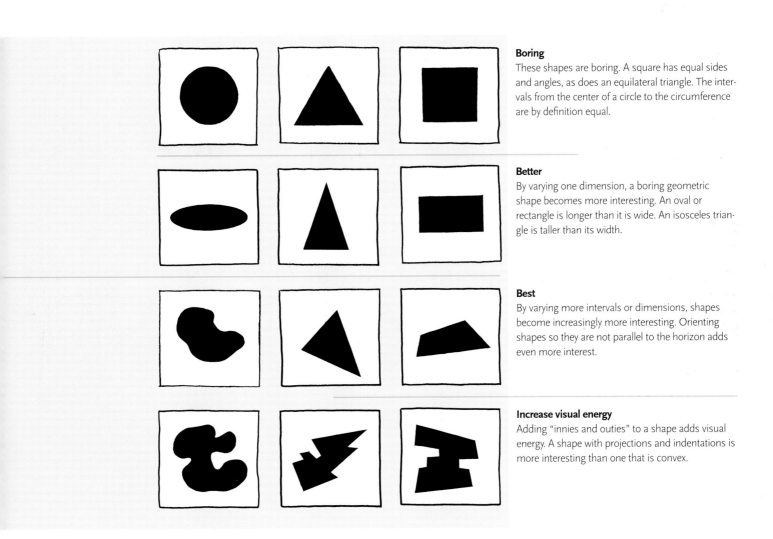

**Boring**

These shapes are boring. A square has equal sides and angles, as does an equilateral triangle. The intervals from the center of a circle to the circumference are by definition equal.

**Better**

By varying one dimension, a boring geometric shape becomes more interesting. An oval or rectangle is longer than it is wide. An isosceles triangle is taller than its width.

**Best**

By varying more intervals or dimensions, shapes become increasingly more interesting. Orienting shapes so they are not parallel to the horizon adds even more interest.

**Increase visual energy**

Adding "innies and outies" to a shape adds visual energy. A shape with projections and indentations is more interesting than one that is convex.

# interesting shapes in common objects

Any object that resembles one of the boring shapes (a circle, square or equilateral triangle) will also be boring. Boring shapes are sometimes hard to detect. A circular flower, a triangular sail or a square window might not be immediately noticed, but each represents an opportunity to add excitement to your painting. In the examples on this page, a boring object is transformed into an interesting object by applying the **One Rule**: *Never make any two intervals the same*.

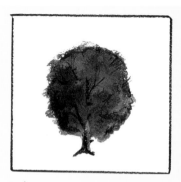

**Boring**
A circular tree is just plain dull.

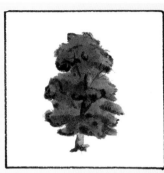

**Better**

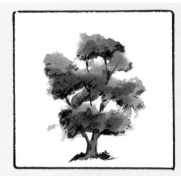

**Best**
A variety of innies and outies creates interest.

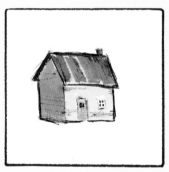

**Boring**
A house with sides of equal length is pretty boring.

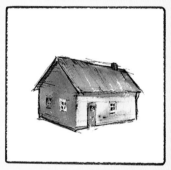

**Better**

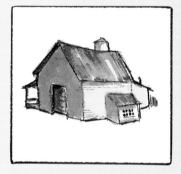

**Best**
An oblique thrust to the house makes it more dynamic.

# interesting shapes: applied

An interesting composition contains varying intervals and interesting shapes. These two paintings were done in very different styles, yet both are replete with interesting shapes. Both are worth studying to see how they comply with the **ONE RULE OF COMPOSITION:** *Never make any two intervals the same.*

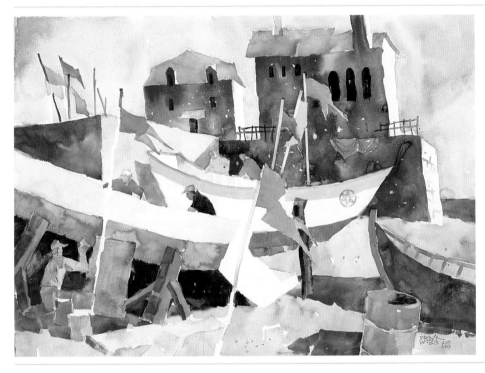

## Complex shapes

The shapes in this painting have sides and angles of different dimensions. They are not parallel to the frame, and they have projections that interlock with the shapes around them.

**Cascais** ✳ Frank Webb ✳ 22" x 30" (56cm x 76cm) ✳ Watercolor on paper

## Simple shapes

Both the dark shapes of the water and the white shapes of the snow vary in size and dimension. No two shapes have the same length or width. While this is a simple painting, it is not at all dull!

**#5** ✳ Jack Reid ✳ 28" x 38" (71cm x 97cm) ✳ Watercolor on paper

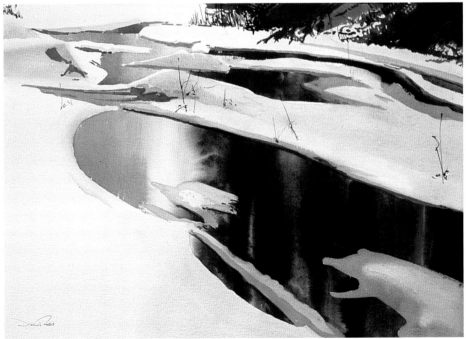

# creating interesting groupings

The **ONE RULE OF COMPOSITION**: *Never make any two intervals the same* also applies to how elements are grouped in various arrangements. A grouping of objects—be they trees, bottles or people—of the same size and with equal spacing is boring.

Odd numbers are more interesting than even numbers. Things that come in threes, fives and sevens especially are more intriguing for the mind, perhaps because it doesn't know what to do with the "one left over." A triangle or pentagon is inherently more interesting than a square because it has an uneven number of sides.

Edgar Whitney, a popular twentieth-century watercolor instructor, had a knack for summing up useful painting concepts in short, memorable sayings known amongst watercolorists as "Whitneyisms." One of his favorite design tricks was to create shapes that were proportioned as "Mama Bear, Papa Bear and Baby Bear." Like the three bears, one shape was large, one was medium and one was small, but they were never arranged in that order. Instead, "Papa Bear," the largest shape, was placed in the middle of the other two, hence "Mama Bear, Papa Bear and Baby Bear!"

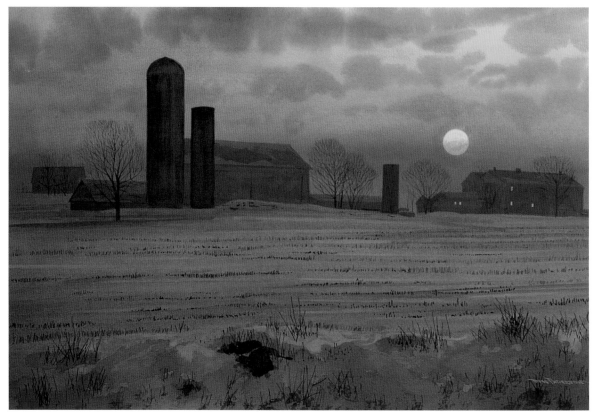

**Uneven groupings provide interest**
The farm structures in this watercolor are interesting because there is no regular, predictable pattern. They are grouped in odd numberings, such as three silos, five buildings and so on. The sizes of the structures and the spacing between them are all different, providing a lot of variety that entertains the eye and mind.

**Wintry Sunset** ❋ Donald W. Patterson ❋ 18" x 27" (46cm x 69cm) ❋ Watercolor and gouache on paper

**Boring: even steps down in size**
The figures are all different in height so there is some variety, but the step-down pattern is boring.

**Better: more dynamic arrangement**
Putting the taller figure to one side in an asymmetrical arrangement is more dynamic.

**Boring: symmetrical arrangement**
Shape, color and texture add interest, but this symmetrical arrangement is still static.

**Better: asymmetrical arrangement**
Placing the taller object to one side creates a more dynamic, asymetrical arrangement.

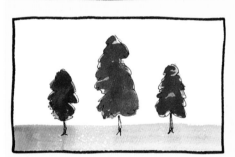

**Boring: trees are the same height**
Odd numbers are more interesting than even. Three is the smallest odd number that is inherently interesting. However, the trees are all the same height, a boring arrangement.

**Better: tree height varies**
This is better: the middle tree is now taller, but it is still a static, symmetrical arrangement.

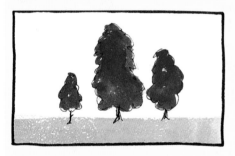

**Even better: mama, papa, baby**
These three trees correspond to Mama Bear, Papa Bear and Baby Bear. This is a pleasing grouping and complies with the **ONE RULE**: *Never make any two intervals the same.*

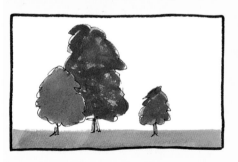

**Best: different heights and spacing**
This is a variation of the three bears. Not only are the three trees of different heights, they are no longer equidistant.

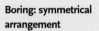

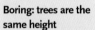

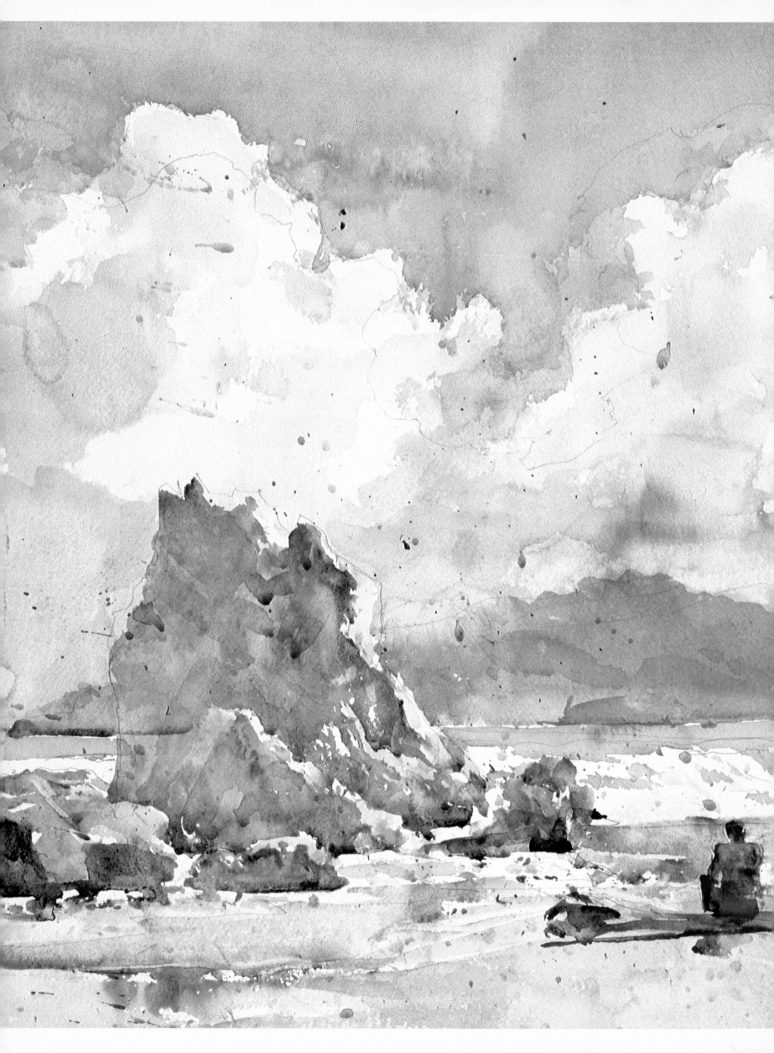

# *achieving* dynamic balance

In this chapter, we will explore how the **ONE RULE OF COMPOSITION**: *Never*

*make any two intervals the same* can be used to create dynamic balance. We

have already seen how complexity in a design creates visual tension. That

tension creates interest in a composition, providing the stimulus that acti-

vates our attention.

However, too much complexity invites visual chaos, which is unpleas-

ant to look at. We need to find the right balance between boring order and

distressing disorder. Too much variation causes a painting to lose unity. Not

enough variation causes a painting to lose interest.

A composition needs **variation** to be interesting,

but that variation needs to be balanced to be coherent. What is needed is

dynamic balance.

● **Grand Rivers, Trinidad** ❊ Charles Reid ❊ 24" x 18" (61cm x 46cm) ❊ Watercolor on paper

# the importance of balance

Balance is a key part of creating a pleasing composition. Imbalance is disconcerting or distracting, so an unbalanced composition can make the viewer feel uncomfortable. There is a reason for the expression "mentally unbalanced": the psychological feeling of being out of balance is as unpleasant as the physical one. Lack of balance suggests incompleteness, irresolution and unpredictability.

A composition lacks balance if its components do not require the viewer's eye to cross over a central axis. If all the visual activity is concentrated on one side of the composition, the viewer has no reason to look from one side to the other. The sense of incompleteness this creates upsets our equilibrium.

If the visual activity is equal or identical on either side

**Unbalanced**
If all the visual activity is on one side of a central axis, the viewer's eye is not required to cross over, and a sense of imbalance is created.

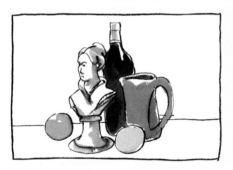
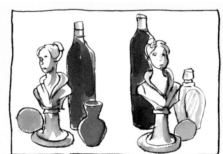

**Static balance**
If all the visual activity is situated on the central axis (*far left*), or if the visual activity is identical on both sides of the axis (*near left*), a static balance is created.

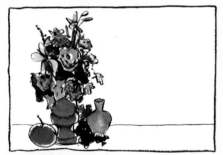

**Cross over the central axis**
When all the visual energy is concentrated in only half of the picture (*far left*), the **ONE RULE OF COMPOSITION** is violated. The viewer's eye does not cross over the central dividing line and an unbalanced, unattractive composition results.

By locating an element with visual energy on the other side of the central axis, the viewer's eye crosses over it and a dynamic balance is achieved (*near left*).

**Diagonal axis**
The central axis is not always vertical. Locating all the visual activity on one side of a diagonal dividing line creates an unbalanced composition (*far left*).

This painting (*near left*) shows how locating an element with visual energy on the other side of the diagonal axis creates a dynamic balance.

of the axis, a static balance is achieved. No visual tension is created and little interest is generated.

When the visual energy is not identical, visual tension is generated and a dynamic balance is achieved. In such a composition we find visual activity that is pleasing to our aesthetic sense.

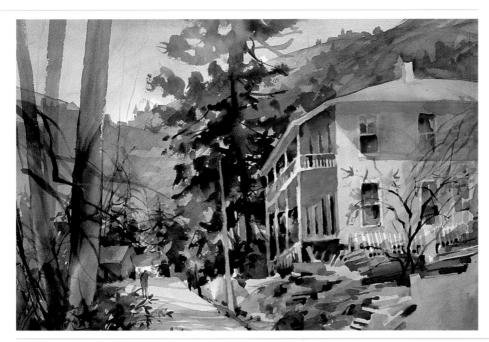

### Energy in balance

In *A Place in the Mountains*, most of the visual energy is on the right. However, the eye is induced to cross over the central axis by the figure and buildings in the lower-left corner. Their very size invites attention. The trees on the left form a block to redirect the eye back into the composition. Together, the figure, houses and trees counterbalance the much larger and more visually active house on the right.

**A Place in the Mountains** ✳ Margaret M. Martin ✳ 22" x 30" (56cm x 76cm) ✳ Watercolor on paper

### A delicate balance

The extreme perspective of the passenger cars on the right pulls the eye into the picture to the focal point of the composition, the distant locomotive. The plume of smoke and the triangular cloud above also direct the eye to that point. The trackside structures on the left balance the visual energy on the right half of the composition. Though small in comparison to the dominant shape of the train, they are sufficient to keep the picture from looking lopsided. These structures also have the important function of keeping the eye from exiting the picture to the left. Without them, the dramatic convergence of the oblique lines from the right would create a velocity strong enough to propel the eye out of the composition.

**Westbound, With Mail** ✳ Ted Rose ✳ 12" x 16" (30cm x 41cm) ✳ Watercolor on paper ✳ Collection of Jay and Linda Jacobs

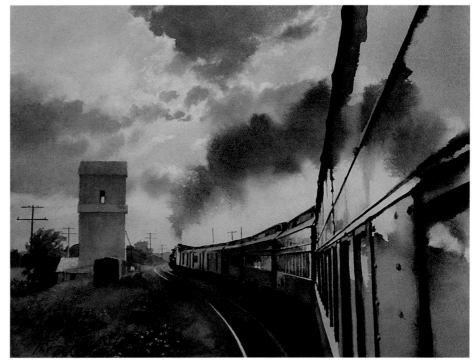

# static versus dynamic balance

Achieving balance is a matter of adjusting visual weight and visual energy. If balance is created with visual elements identical in both weight and energy on either side of a central axis, a static balance is achieved. Static balance does not follow the **ONE RULE OF COMPOSITION:** *Never make any two intervals the same.*

If the balance is created with two visual elements that are not identical in weight and energy, a dynamic bal-

ance is achieved. Intervals are not the same and the **ONE RULE OF COMPOSITION** applies.

Static balance is also called *formal, classical* or *symmetrical* balance because it is based on an equal or even (symmetrical) arrangement along a central axis. Dynamic balance is also called *informal* or *asymmetrical* balance and is based on an uneven arrangement.

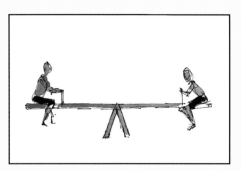

**Static balance**
When children of the same weight are equidistant from the center, they balance perfectly and the seesaw remains level.

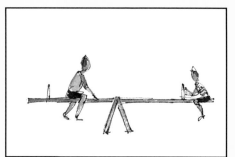

**Dynamic balance**
If one child is bigger and both are equidistant from the center, the seesaw doesn't remain level. To keep the seesaw level, the bigger child must move closer to the center, or the smaller child farther from the center.

**Symmetrical arrangement**
Avoid centering things. The center is the most boring part of the painting. Symmetrical compositions are naturally static.

**Asymmetrical arrangement**
Although the image is still centralized, the tree and house are asymmetrically arranged and visual interest is increased.

**Static balance**
The tree and the house have identical visual weight and energy. A static balance is created.

**Dynamic balance**
The house and tree on the left have greater visual weight, but the house and tree on the right counterbalance the weight, creating a dynamic balance.

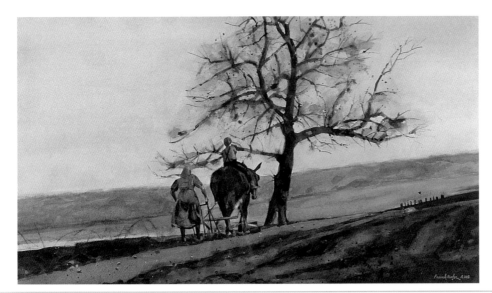

**Central but asymmetrical subject**
Although the subject matter is centralized in this composition, the elements are asymmetrically arranged, creating visual interest. If Frank had placed a figure on both sides of the tree, a more static and less interesting arrangement would have resulted.

**Spring Plowing** ❋ Frank Nofer, AWS ❋
9" x 12" (23cm x 30cm) ❋ Watercolor on paper

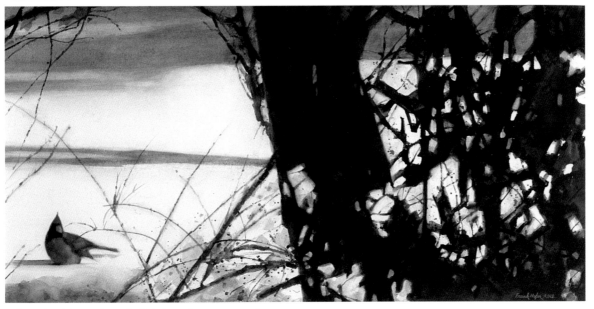

**Color and weight are dynamically balanced**
The small red bird on the left perfectly counterbalances the dark mass of thickets on the right. The viewer's eye crosses the central axis back and forth, creating great visual interest.

**Beyond the Thicket** ❋ Frank Nofer, AWS ❋
14" x 27" (35cm x 69cm) ❋ Watercolor on paper

# balancing visual weight and energy

Dynamic balance is achieved by adjusting the visual weight and energy of a painting's components so there is enough variation to be interesting, but not so much that the picture loses coherence. If the components are equal in terms of visual weight and energy, a boring static balance occurs. If the components are too dissimilar or unequal, an imbalance will occur.

Two components can be dynamically balanced by adjusting their visual weight or visual energy. A visually heavy element can be countered by a sufficiently energetic element. Size, color, complexity and many other characteristics can be adjusted to create a visually exciting balance. For example, a brightly colored or strongly textured object can balance a larger, but dull-colored or untextured shape.

**Weight**
The larger shape on the left is balanced by the heavier, smaller, darker shape on the right.

**Energy**
The larger shape on the left is balanced by the smaller shape with greater visual energy on the right.

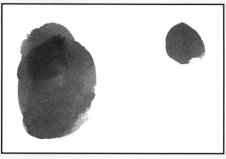

**Color**
The larger, cooler shape is balanced by the smaller, warmer red shape on the right.

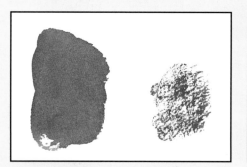

**Texture**
The larger flat shape is balanced by the smaller shape with greater texture on the right.

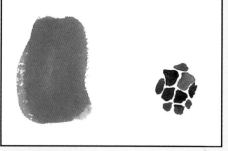

**Complexity**
The more complex pattern on the right counterbalances the simpler shape on the left.

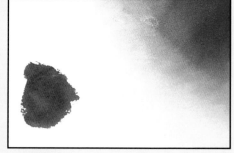

**Gradation**
The solid shape on the left is counterbalanced by the gradation in the opposite corner.

**Distance**
The sheer expanse of space on the right of this elongated frame counterbalances the weight of the shape on the left.

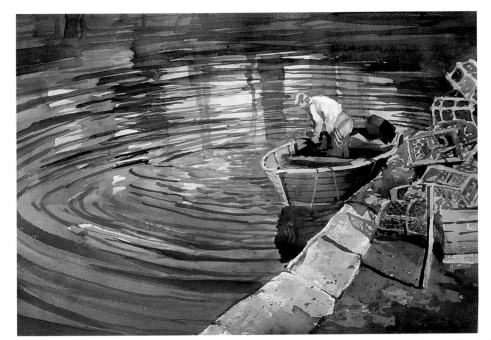

**Detailed water counterbalances the center of interest**

The center of interest of this composition is concentrated in the lower-right corner. If not for the visual activity of the ripples and reflections in the rest of the painting, it would be lopsided, inviting the eye to fall out of the picture through the lower right. The artist used the concentric rings of rippling water to pull the eye back in.

**First Impressions** ※ Jeffrey J. Watkins ※ 11" x 14" (28cm x 36cm) ※ Watercolor on paper

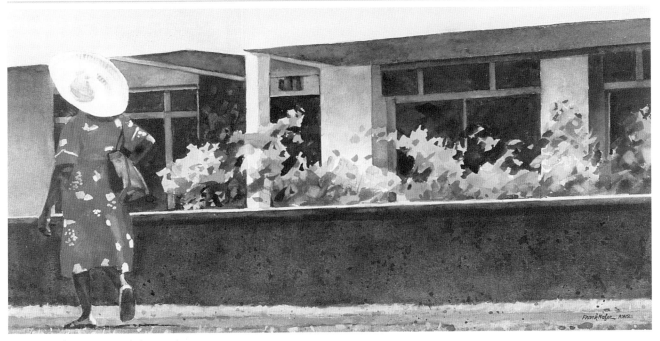

**Distance and space counterbalance color**

The red dress has both visual weight and energy, with no other object to the right for balance. Therefore Frank included the expanse of wall and building to balance it. Because the figure faces left and appears to be moving toward the left, our attention would drawn out of the composition if not for the counterweight of space on the right.

**The Lady in Red** ※ Frank Nofer, AWS ※ 10" x 19" (25cm x 48cm) ※ Watercolor on paper

# pleasing
# the eye

In this chapter, we will look at how viewers are most likely to scan your painting. With this information, you will be able to consciously determine the path that the viewer's eye will follow as it investigates your picture. If you manage to attract and retain your viewer's attention while pleasing or fascinating him, your painting will be a compositional success.

Good composition is the result of conscious planning on your part. It doesn't happen by accident. The time to do this conscious planning is before you start to paint. You need to

**carefully consider how the viewer is going to look at your painting,**

and **design** the painting accordingly.

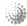

How and why we look at something is the basis for our **ONE RULE OF COMPOSITION**: *Never make any two intervals the same*. When the intervals vary, the eye has more to scan. If too many of the intervals are the same, the viewer can figure out the pattern quickly and move on without an entertaining exploration. With a variety of intervals, the viewer's eye must trace through the picture. Unable to discern the pattern at first glance, it lingers to figure it out. This game amuses the eye. It's fun and that makes the painting more interesting.

● **Pumpkin Time** ✳ Rod Lawrence ✳ 10" x 7" (25cm x 18cm) ✳ Acrylic on panel ✳ Private collection

# path of the eye

The viewer's eye follows a definite path through the painting as it is scanned. The artist can use strategies to deliberately control this path. Our job as artists is to make the path as interesting and as enduring as possible. We don't want to create an easy exit for the viewer's eye; we want to invite a long and pleasantly entertaining stay within the boundaries of the painting. We also want to create in the viewer the desire to return for another look.

When a child learns to read, he learns to start at the upper left of the page and moves down toward the right. After twelve years of schooling and a lifetime of reading, starting in the upper left becomes an ingrained habit. Because this is such a strong tendency, we usually look at a painting by scanning it the same way. The upper-left corner then is a good entry point for the viewer.

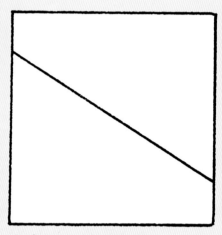

**Going from upper left to lower right**
Most people would describe this line as going from the upper left down to the right. Why? Because it aligns with the visual path we usually follow as we read, from upper left to lower right.

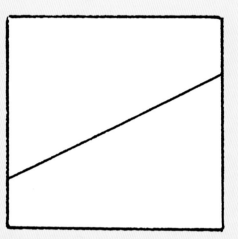

**Going from lower left to upper right**
Most people see this line as going up from the lower left to the upper right because reading from the right to the left contradicts the normal path of the eye.

**Left to right**
These lines "go with the grain," that is, they seem to follow the eye's tendency to scan from left to right.

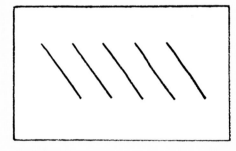

**Countering the norm**
These lines counter the normal path of the eye and therefore look more energetic.

# compositional "magnets"

A good painting has to be about something. It must have a specific subject that attracts and holds the viewer's attention. Without a subject, a painting appears empty or incomplete, quickly boring the viewer.

Every painting needs to have one main area of interest, the reason the painting was created in the first place. The painting can evoke a mood, express emotion or inspire some reaction in the viewer, but it does that by making a statement about its subject. Even a nonrepresentational painting needs a main area of interest to avoid being glorified wallpaper.

In other words, every picture needs a dominant feature that acts as both a magnet and an anchor. As a *magnet*, it must be an almost irresistible attraction that

pulls the viewer in. As an *anchor*, the dominant feature keeps the eye from drifting away once it has been captured. A painting does this by being both visually and psychologically compelling.

Magnets for the viewer are of two types: a *focal point* and a *center of interest*. The focal point of a painting is the spot that attracts the *eye* of the viewer because it is visually appealing. The center of interest is the spot that attracts the *mind* of the viewer because it is intellectually appealing.

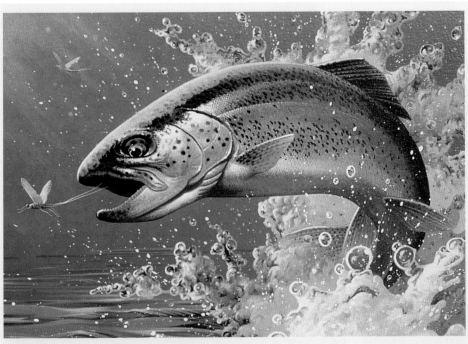

**Rainbow Trout** ✳ Rod Lawrence ✳ 7" x 10" (18cm x 25cm) ✳ Acrylic on panel ✳ Private collection

**Lead the eye**
In this painting, the viewer is first attracted to the strongest eye magnet, the fish's mouth, which is the main center of interest. Once it has gathered information about that area of the picture, the eye quickly moves on to another eye magnet, the fly. Then it will go to the next most interesting point, the splash of water to the right. From there it will follow the curve of the fish's bottom back to its mouth, from which the circulatory path through the picture originated.

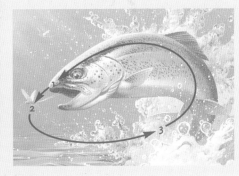

# center of interest

The center of interest is a magnet for the mind. It is where the viewer wants to look to find information. Two elements may be visually identical in terms of contrast or energy, but if one offers more meaning, that is where the viewer looks first.

The best example of something in a picture that attracts the mind is a figure. We can't resist the human presence in a scene.

A landscape without a figure often appears oddly and, perhaps, disturbingly vacant. Even if the subject from which you are working doesn't include people, consider adding them. Remember, they will become the picture's center of interest, so use the devices mentioned on **page 45** to make the figures an eye-arresting focal point.

Also, be careful about including words or numbers in your picture. They can unintentionally become a competing center of interest, stealing attention from where you want the viewer's eye to go.

## subjects that attract the mind

- Faces
- People
- Words & numbers
- Directional symbols
- Things in motion (runner, airplane)

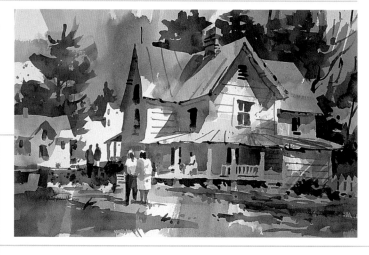

**Demand closer study**
The eye is naturally attracted to the figures in front of the house. Visually, other points of the picture are as attractive to the eye, but the mind naturally picks out the figures for closer study.

**Pocono Impressions** ✳ Tony Van Hasselt ✳ 15" x 22" (38cm x 56cm) ✳ Watercolor on paper

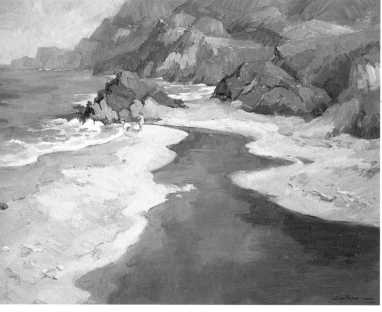

**Lead the eye**
The eye naturally follows the strong blue path of the water right to the figures on the beach, making them a powerful center of interest.

**Tidepool** ✳ Louise DeMore ✳ 30" x 40" (76cm x 102 cm) ✳ Oil on canvas

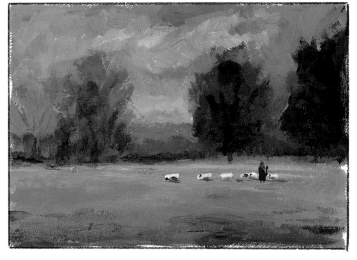

**Give life to a landscape**
Although reduced to almost unidentifiable spots of color, the eye is drawn to the figurative shapes in the landscape.

**Shepherd and Flock** ✳ Greg Albert ✳ 9" x 17" (23cm x 43 cm) ✳ Acrylic on watercolor paper

# focal point

A focal point is a magnet for the eye. It is a feature in a composition that draws the viewer's eye to it. The viewer will look first at any part of a painting that has these characteristics:

- **Contrast in tonal value**
- **Concentration of visual energy or detail**
- **Bright or intense color**
- **Hard edges**
- **Gap in a pattern**
- **Anomalies in a pattern**
- **Tangents**
- **Intersections or convergence**

All of these are really different types of contrast. What attracts the eye is some sort of contrasting characteristic that makes an element stand out because it is unlike any other. In the examples on this page, notice how the eye is attracted to the contrasting element.

You can use any of these characteristics to make a particular feature in your painting a magnet for the eye, but there should only be one dominant feature, one "star." The focal point and the center of interest should be one and the same. In other words, the eye and the mind should be attracted to the same spot. If there are competing features, such as two focal points or two centers of interest attracting the mind, the viewer doesn't know where to look.

Contrast in tonal value

Concentration of visual energy or detail

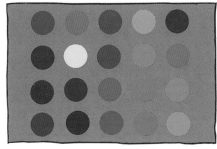

Bright or intense color

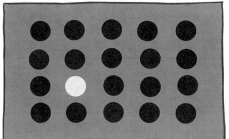

Hard edges

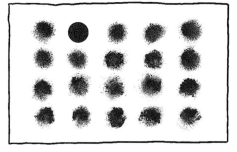

Gap in a pattern

Anomalies in a pattern

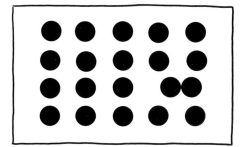

Tangents

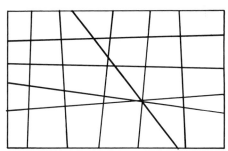

Intersections or convergence

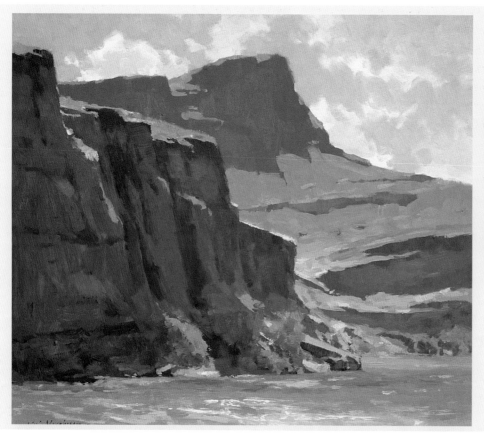

## Color and value draw the eye

The focal point of this painting, at the left, is created by color and value contrast at the base of the rock cliff in the foreground.

**Paria** ✳ Kevin Macpherson ✳ 20" x 22" (51cm x 56cm) ✳ Oil on canvas

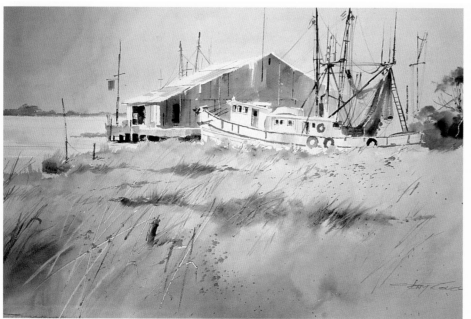

## Detail and value draw the eye

The focal point is at the upper left and is formed by sharp detail and value contrast. Note how the boat's bow points to this area, as do the diagonals from the left.

**Catch of the Day** ✳ Tony Couch ✳ 20" x 33" (51cm x 83cm) ✳ Watercolor on paper

# placing the focal point

The overall effectiveness of a painting's design will be a function of the location of its focal point and center of interest. Luckily, the **ONE RULE OF COMPOSITION:** *Never make any two intervals the same* can be used to find the right place every time. The focal point should be located in a place that is at a different distance from all four sides of the picture.

## The Rule of Thirds

The **Rule of Thirds** says to divide your picture into thirds vertically and horizontally. (Think tic-tac-toe).

The intersections of the two horizontal dividing lines and the two vertical lines create what I call the four *sweet spots*. Any one of these intersections is a good location for the center of interest because each location is unequally distant from the four sides.

An alternate way to locate the center of interest is to divide the format into four equal quadrants. The center of each would be a good position for your primary subject. Either method will give you an interestingly off-center place to put the focal point.

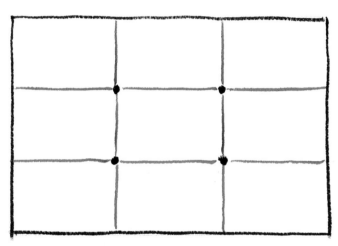

**Divide the picture area as for tic-tac-toe**
Divide the picture into thirds vertically and horizontally. The intersections of these divisions form the best locations for your picture's center of interest.

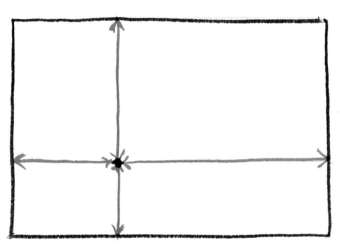

**Find the intersection of thirds**
Each point determined by the **Rule of Thirds** is a spot at different intervals from all four sides, complying with our **ONE RULE OF COMPOSITION:** *Never make any two intervals the same*.

**Use *sweet spots* as guides**
The center of interest does not have to be at the exact point the **Rule of Thirds** indicates. Close is good enough.

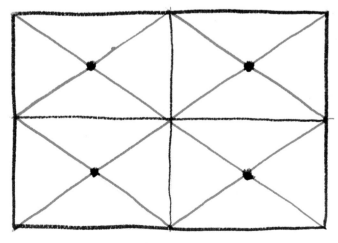

**Divide the picture area into quadrants**
An alternate way to locate good positions for the center of interest is to divide the format into four equal quadrants and find the center of each.

# exploring the four "sweet spots"

Once you become aware of how to locate a center of interest with the **Rule of Thirds**, you'll discover that this idea has been repeatedly used by many great artists. It is a very easy method to remember and use (just think tic-tac-toe). But beware: Even when you do remember to use it when planning your painting, the urge to put the center of interest in the geometric center is very strong. If you're not careful, you might find that the center of interest has drifted toward the boring center despite your use of the **Rule of Thirds**.

The **Rule of Thirds** is one of the handiest applications of the **ONE RULE OF COMPOSITION:** *Never make any two intervals the same*. If it is the only way you practice the **ONE RULE**, you will find that it almost automatically improves the design of your compositions.

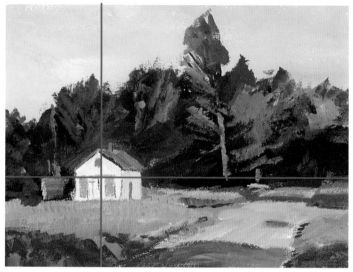

**Locating the focal point**
The white house in the field, located at one of the *sweet spots*, is the focal point of this picture.

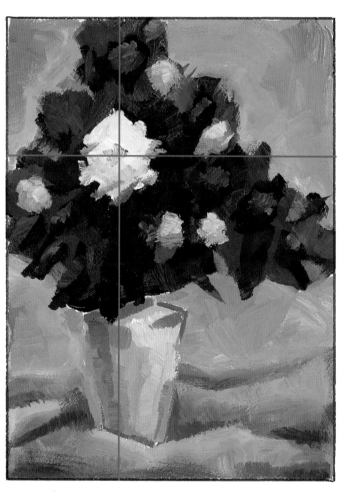

**Occupying the *sweet spot***
The center of interest is the largest, brightest flower in the upper left. It occupies a sweet spot.

# lines, leads and pointers

Directing the viewer's attention as she scans your picture is part of your job as an artist. You can control what the viewer sees and when the viewer sees it. You also want to keep the viewer's attention freely circulating. You can accomplish both by the use of *lines*, *leads* and *pointers* which direct the eye to where you want it to go, and by avoiding *leaks* that allow it to escape.

You want to provide a clear visual trail for the eye to follow through the picture. Lines, leads and pointers form the path of least resistance, naturally attracting a viewer's attention. Any linear element in a picture, such as a line or long, narrow shape, will create a path for the eye to follow. An arrow-like shape can act as a pointer, too, directing the eye to wherever it points. These devices can lead the eye out of the picture as well as into it, so you need to be aware of their affect on the viewer's attention.

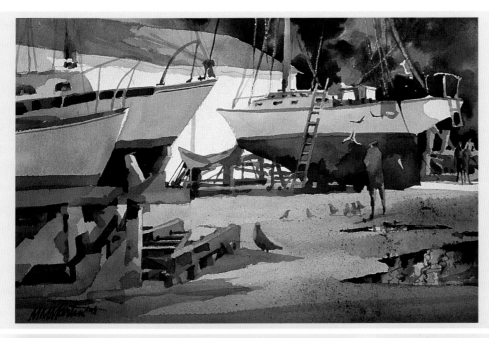

**Shapes lead the eye**
The shapes in this painting, including the boats, lead the eye into the painting and keep the viewer from straying out.

**Marina Friends** ✳ Margaret M. Martin ✳ 22" x 30" (56cm x 76cm) ✳ Watercolor on paper

**Diagonal lines**
Diagonals; naturally dynamic lines in a composition, form powerful pointers to the focal point.

**Zigzag lines**
A meandering line leads the eye to a focal point at a more leisurely pace than a straight diagonal. Don't let it run into a corner, and apply the **One Rule:** *Never make any two intervals the same* by making sure the angles and lengths of the "zags" are different.

# blocks and exits

As obvious as it sounds, you want to direct lines into the painting, toward the interior and not toward the periphery. However, any line has the potential to lead out as well as lead in. As important as knowing what to do to keep the eye within the frame, is knowing what to avoid in order to keep the eye from drifting out.

## Avoid leaks and drains

A line from edge to edge will pull the eye right through a painting. In fact, any line that touches the edge of the painting's format is a potential eye leak. A line touching the edge provides a ready exit for the eye right out of the picture by drawing attention to the edge.

A line that touches a corner of a painting is like a drain. Because the corner is where two edges (both places where the eye can drop out of the painting) meet, the outward pull is strong. Any line that directs the eye to a corner is an invitation to leave the picture entirely.

## Create blocks and eye magnets

To keep the eye from following a line out of a picture, you need to use *view blocks* as well as eye magnets. A view block can be a line, shape or some other graphic element that stops the eye on its way toward the edge of the picture. It blocks the eye from following the path out of the picture and redirects it back in.

View blocks are usually placed close to the edge or in the corners of a picture. In a horizontal format, the blocks would normally be placed on the right or left edge, since the eye naturally follows the horizontal orientation to those edges. The eye is less likely to fall out the top or bottom. View blocks are more often placed in the lower corners than the upper ones.

By using a combination of blocks and eye magnets, you can keep the viewer's attention inside the picture.

**Don't run lines into corners**
Corners are natural drains for the eye. Every corner of this painting has a diagonal leading the eye out of the composition.

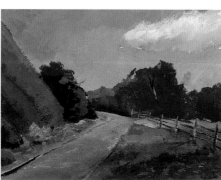

**Don't place figures facing out**
Don't play "made you look" with the viewer by placing a figure looking toward a nearby edge of the painting. This naturally attracts attention outside the composition.

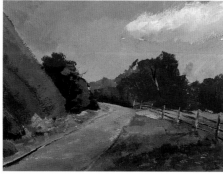

**Don't place shapes tangent to the edge**
These tangents become unwanted focal points that lead the eye right out of the picture.

**Don't place lines leaning out**
Don't direct the eye to the edge of the format with lines that thrust away from the center of the painting.

# attract, entertain and retain the viewer

A good composition will attract, entertain and retain the attention of the viewer. In this chapter, we examined ways to invite the viewer's eye into the picture and then create a path that circulates it within the borders of the composition. By carefully considering how the viewer is likely to scan his picture, the artist can create a compelling piece of art.

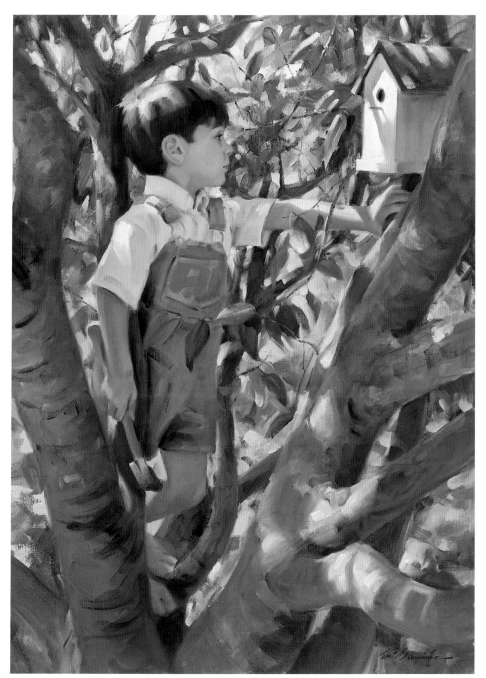

**Provide a path for the viewer's eye to follow**

In this painting, the spreading limbs of the tree funnel the eye upward, and act as view blocks to keep the eye from wandering off to the right or left. The oblique thrust of the tree limbs generate a visual energy that animates the whole composition.

There are two eye magnets, the boy's face and the birdhouse, both located at sweet spots as determined by the **Rule of Thirds**.

The boy's face is a center of interest because the eye naturally is attracted to faces; so much important information for social interaction is conveyed by facial features. The birdhouse is a focal point because its "face" is the brightest spot in the picture. Tom has arranged the composition so the boy and the birdhouse are facing each other, compelling the eye to go back and forth from one to the other.

Other minor focal points, such as the hammer in the boy's hands and the spots of sunlight on the tree limbs, circulate the eye as it scans the picture: face, birdhouse, hammer, face is the circular path the eye generally follows.

Although the face and birdhouse are equally balanced, the visual weight of the picture is centered on the left where the boy is standing. On the right, the birdhouse and light-dappled limb from which it hangs counterbalance the composition dynamically.

**The Landlord** ❊ Tom Browning ❊ 30″ x 24″ (76cm x 61cm) ❊ Oil on canvas

# tonal value
# and contrast

Tonal values are critical. The lights and darks contribute more to the success

of a painting's composition than any other factor, including color. In fact,

your painting will really be only as good as its tonal values.

Value contrasts attract and entertain the viewer. Points of contrast pro-

vide touchstones for the eye as it scans the picture.

**Value contrast** is so compelling that it is

**the best way to establish a strong focal point.**

Value contrast will make any part of a picture an eye magnet.

To be effective, the lights and darks in your paintings must at least be

consciously considered if not deliberately planned. This planning does not

need to be difficult or time-consuming. All it takes is a preliminary sketch

before starting the painting and the application of the **ONE RULE OF COM-**

**POSITION**: *Never make any two intervals the same.*

● **Santa Clara Coppersmiths** ✳ Gerald J. Fritzler, AWS ✳ 19" x 14" (48cm x 36cm) ✳ Watercolor on paper

# the importance of value contrast

The success of your painting depends on value more than any other element. Good tonal value contrast attracts the viewer's attention and creates clarity.

Compare the examples on this page. The picture with a wide range of tonal values, from light to dark, and strong contrast is the most appealing. Notice that the words in the examples (*left*) strongly contrast with the background, making them easy to read. More paintings are weakened by the lack of value contrast than in any other compositional failing.

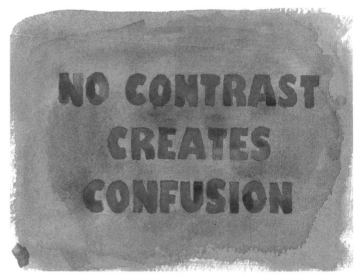

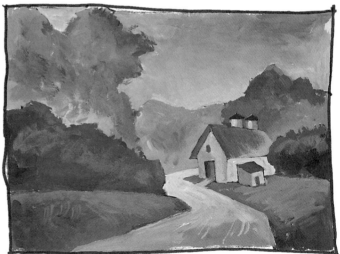

**Strong contrast**
Strong tonal value contrast increases the clarity of your paintings and attracts and retains the viewer's attention.

**Weak contrast**
Lack of value contrast can weaken your painting. It is important to provide at least one element of strong contrast.

# vary your values for interest

If you think of a value scale as a series of grays from black to white, you can see how the intervals between each step of the scale are the same. According to the **ONE RULE OF COMPOSITION**, if a painting has little value contrast—that is, if there is little difference between the darkest and the lightest tonal values in a picture—no part of the picture will be particularly attractive to the eye. If a picture has only darks, only lights or only middle grays, nothing will stand out sufficiently to be a focal point. If you vary the intervals between values so there is no longer an equal interval between each, you create a more interesting proportion of values.

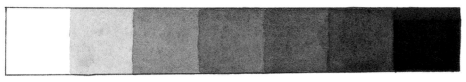

**Boring, even intervals of value**
This value scale has equal intervals. Each step changes to the same degree as the one before and after. This scale is boring because the eye and mind can determine the pattern quickly.

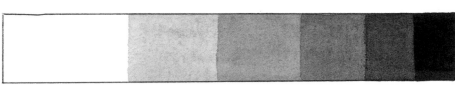

**Heavy on the lights**
This value scale is weighted toward the light side. It is more interesting than an evenly distributed scale.

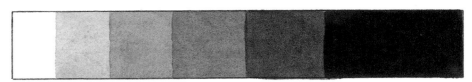

**Heavy on the darks**
This value scale is weighted toward the dark side. There is an uneven, irregular change from step to step, producing interest.

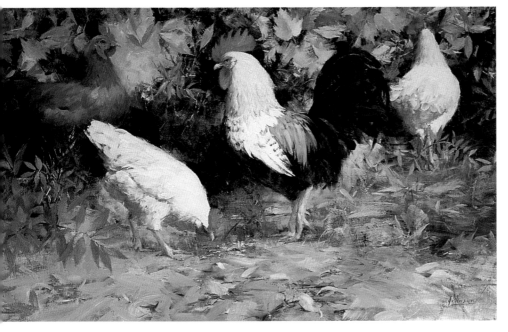

**Use a range of values with varied intervals**
The values in this composition are a good example of *Mostly, some and a bit* (see page 70 for more about this formula). The painting is made up of *mostly* mid-value, *some* black and three *bits* of white.

**November Chickens** ✳ Robert Johnson
✳ Oil on canvas ✳ 24" x 40" (61cm x 102cm)

# seeing your subject as a pattern of values

Before you can make the most of the tonal values in your paintings, you need to develop an awareness of them in your subject matter. The first step is to start looking through (or past) the surface details of your subject, seeing it as a simplified pattern of lights and darks.

To see your subject as a pattern made up of value shapes, you have to look at your subject not as a group of things that can be named, but as a pattern. Instead of thinking *tree* or *vase*, think *dark shape* or *light shape*. What an object *is* is not as important as its shape and value.

**Simplify the shapes first**

Use a pen or pencil to create a simple drawing, reducing your subject to a few big shapes. Eliminate details and combine small shapes into larger shapes. Link shapes of similar value or combine them into larger shapes. Think big shapes; don't think detail.

**Reduce the values to a few**

Once you have simplified it, use black and white to make this pattern of shapes into a pattern of tonal values. Although the eye can see an almost unlimited range of tonal values and is capable of perceiving subtle distinctions, you need to use only a few contrasting values.

**Reference photo**

This way of seeing can be learned with a little practice, and the best way to practice developing an awareness of tonal value patterns is to make drawings that simplify the subject into a pattern of *shapes*, then turn the pattern of shapes into a pattern of *values*.

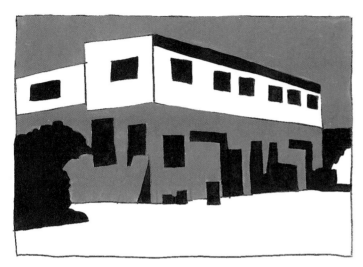

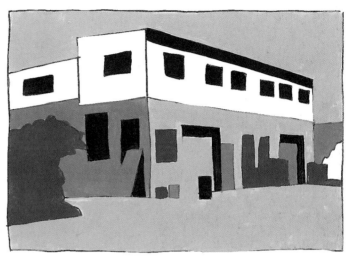

## Using three values

Reduce your subject to three values: black, gray and white. All light shapes become white, all dark shapes become black, everything else is gray.

Most subjects will lend themselves readily to a reduction of three values. You'll find that you will have to make some judgment calls when assigning labels, but less so than with only black and white. If using only three values, your first impulse might be to label everything gray because nothing is totally black or absolutely white. Instead, you'll have to exaggerate the differences by making the darker shapes black and the lighter shapes white.

Try labeling the shapes B, G and W (black, gray, white) like a paint-by-number. Doing so encourages you to see the larger pattern of tonal values—the shapes that will be the strongest in your composition.

## Using five values

Reduce your subject matter to five values: white, light gray, middle gray, dark gray and black. This value reduction still keeps the pattern simple, but allows for enough value distinctions to make the identity of your subject matter clearer.

If adjacent shapes are close in value, you may need to assign them different values to distinguish them from each other.

Five is a comfortable number for practicing with value patterns. It is easy to mix three grays that are sufficiently different for this purpose. Using more than three grays with the black and white requires careful mixing and renders little benefit for the extra effort.

# basic value patterns

Once you start thinking about your picture as a pattern of value areas, you can check to see if that pattern forms an effective composition. Some patterns are more effective than others. In fact, there are some models that are almost guaranteed to make your pictures more effective.

Simple to remember and use, these patterns consist of only three values: dark, middle and light. (Since we rarely use pure black or white when painting, it is easier to think of dark and light).

By varying the proportional amount of area occupied by each value, you will naturally comply with the **ONE RULE OF COMPOSITION**. Varying the values this way is much more interesting than dividing them equally. In each case, the smallest area naturally becomes the center of interest. The largest value area becomes the dominant value group. (If the largest value area is light, the painting is said to be in a high key; if the largest is dark the painting is in a low key.)

When there is an equal distribution of values, it is more difficult to create one spot with enough contrast to act as the focal point. All three values compete for attention. When unequally divided, the smallest area, because of its contrast in both value and size, wins the battle for the viewer's attention and becomes the "star."

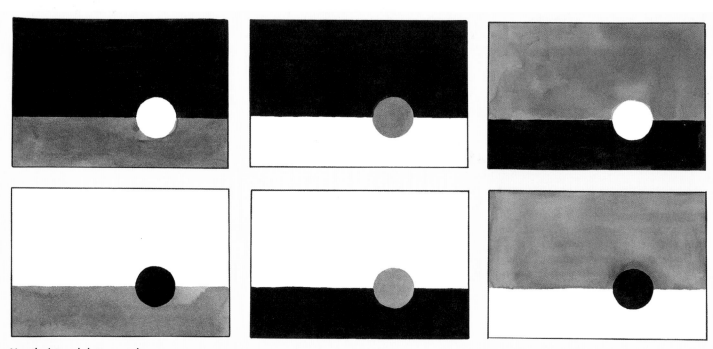

**Vary the intervals between values**
Each of these two basic value patterns is divided into three areas of different sizes and values, resulting in six possible variations. The smallest area, located at one of the sweet spots, is the natural center of interest.

# lead the viewer's eye to your focal point

The artist has employed one of the basic value patterns, a white shape containing a dark shape placed on a mid-value field. The monastery is the light shape, making it the visual focal point. The ladder-like bands of shadow and the converging road lead the eye toward this point; the peripheral darks keep the eye circulating within the composition. The focal point is located at one of the off-center sweet spots.

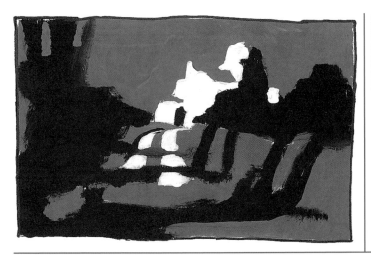

**A basic value pattern**

**Spanish Monastery** ✳ Jack Lestrade ✳ 19" x 28" (48cm x 71cm) ✳ Watercolor on paper

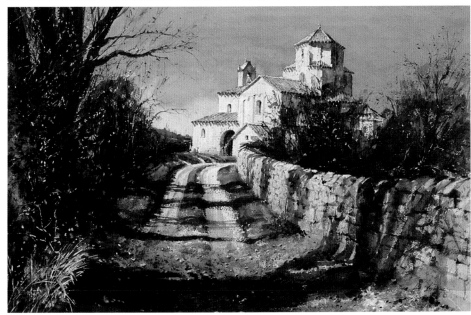

# use values to enhance mood

This picture is a good example of how a value pattern can enhance the mood suggested by the subject matter. The dog is a simple dark shape set against a high-key background. The animal is balanced and contrasted with the brighter, busier folds of the quilt on the right. The contrast makes the dark shape look very passive, even inert—appropriate for a sleeping dog. The mood is one of quiet rest in the shadows. Bright eyes twinkle from the dark fur of the animal's head (located at one of the sweet spots), creating an irresistible center of interest.

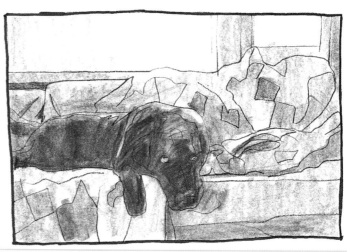

**Guilty Pleasures** ✳ Sueellen Ross ✳ 13" x 19" (33cm x 48cm) ✳ Ink, watercolor and colored pencil on paper

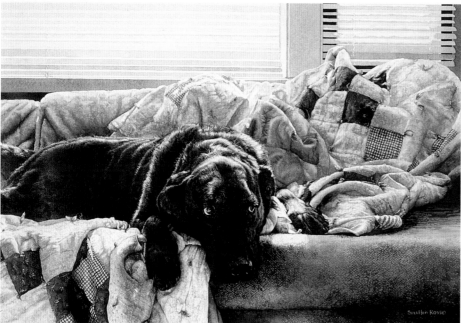

# turn the ordinary into the extraordinary

This elegant landscape painting is a good example of how a strong, simple value scheme can make a powerful picture of an ordinary scene. Although the colors are clean and the brushwork is descriptive and economical, the lights and darks are what makes the piece so compelling. There is minimum detail, but maximum impact. The focal point is located at the bottom of the dark shape of foliage on the left. The sunlit rocks against the deep shadow create an eye-catching area of contrast. The secondary focal point is the cactus silhouetted against the distant mountain. Because the contrast there is less stark than at the rocks below, the cactus becomes a subordinate attraction for the eye and provides an interesting balance.

**Table Mountain** ✳ Kurt Anderson ✳ 14" x 11" (36cm x 28cm) ✳ Oil on canvas

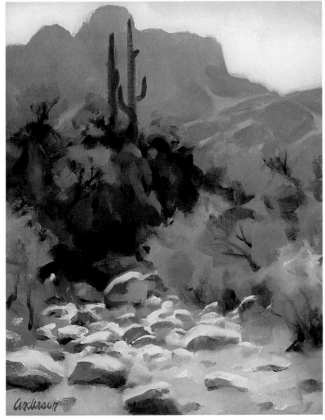

# gradation of value creates interest

While value contrast is a great technique for attracting the viewer's attention, gradation of value is a great technique for retaining it. *Gradation* is the gradual change of tonal value from light to dark over distance. The transition is not sudden, but blended from one area to another.

Gradation, by its very nature, complies with the **ONE RULE OF COMPOSITION:** *Never make any two intervals the same*, because gradation entails constantly changing.

A shape with a single value overall can be monotonous and boring. However, if the value changes within that shape, there is more for the eye to examine and explore, which makes it more interesting. If the adjacent shapes show a contrasting gradation, the eye and mind have more to scan, which makes that part of the composition even more appealing.

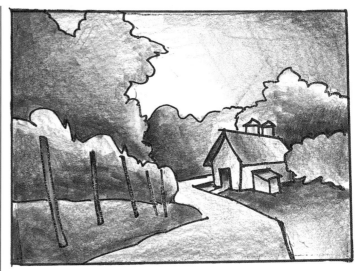

**Value changes within shapes**
The gradations of each shape go back and forth between light and dark.

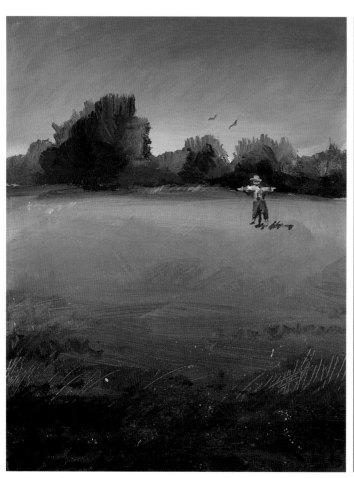

**Gradations draw in the eye**
The gradual change in tonal value in the foreground pulls the eye into the picture. A value area that has both contrast and gradation attracts and retains the viewer's attention, creates depth in a picture, and helps focus the eye on a center of interest.

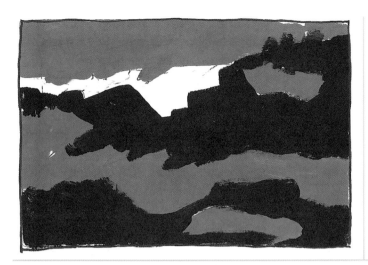

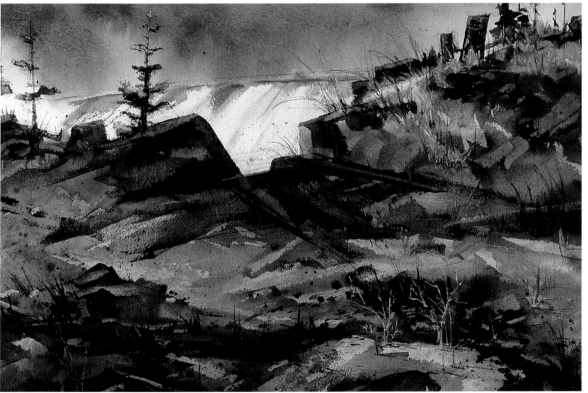

**Value changes keep the eye moving**
The alternating pattern of light and middle values
with one chunk of light anchors the eye. The variety
of textures and gradations on the rocks "tickles the
retina" and keeps the eye circulating.

**Mud, Rocks and Water** ❄ Joan Rudman ❄ 30" x
36" (76cm x 91cm) ❄ Watercolor on paper

# harmony within value contrast

Arthur Wesley Dow, an influential teacher of the late nineteenth century, introduced the Japanese word *notan* for pleasing value contrast in design in his classic book *Composition: A Series of Exercises in Art Instruction* (Doubleday & Co: 1929). The word in Japanese means *dark-light*. Notan, however, is a concept much more profound and subtle than merely dark-light contrast. Notan expresses the beauty and harmony of darks and lights balanced together or interacting in what the Japanese call *visual music*.

The concept of notan includes figure-ground relationships formed by dark shapes against light and light shapes against dark. (In this case, figure refers to any object or shape set against a background, not just to a human figure). Notan combines all that makes shape and value contrast interesting: variety in dimension, concavity and convexity, interlocking, figure-ground ambiguity and dramatic opposition.

Dow recommended reducing a composition to its basic dark and light pattern by rendering it in pure black

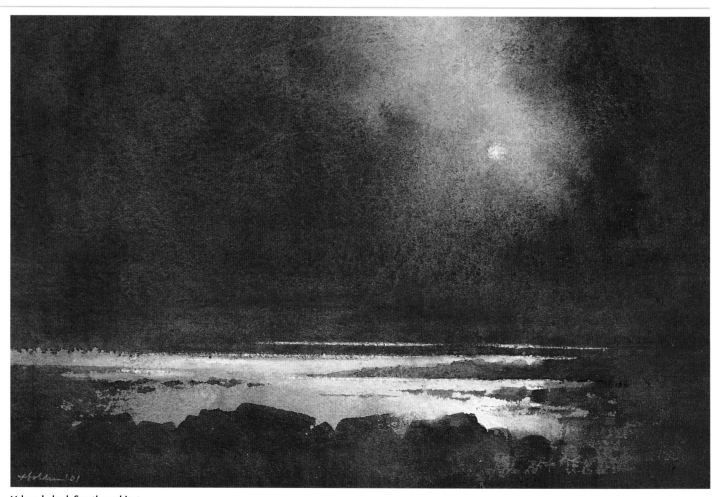

**Values help define the subject**

This painting works well as a purely abstract value pattern, even without reference to a real landscape, and is therefore a good example of *notan*. Nevertheless, there are just enough visual clues to identify the subject matter: water, surf, rock and cloud are all expressed in this moonlit landscape. Soft and hard, smooth and rough, light and dark are all contrasted to make a seemingly simple picture one of subtle mystery.

**Lobster Cove 1** ✳ Donald Holden ✳ 7 ¼ " x 10 ¾" (18cm x 27cm) ✳ Watercolor on paper

and white shapes. If this underlying foundation was interesting, the composition was successful. All the shapes, both positive and negative, must be interesting shapes in themselves with varying intervals. Their interaction should create harmony and balance.

Notan utilizes the potential of ambiguity in the figure-ground relationship; sometimes the white in a design appears to be the figure or positive shape on a black background, and sometimes the black in the same design appears to be the figure or positive shape on a white background. Neither the white nor the black dominates. The result is a fascinating game for the mind to play, one that follows the **ONE RULE OF COMPOSITION:** *Never make any two intervals the same.*

**Values intensify drama**
Don Holden is an artist who believes "that a painting must be (before anything else) a satisfying arrangement of positive and negative shapes." This painting is an example of his use of black and white design principles to build his composition. A series of dark violet verticals are interrupted by flares of hot color. The widths of the intervals and the spaces between them are varied to intensify the drama of a raging forest fire.

**Forest Fire XI**  ※  Donald Holden  ※  7 ¼" x 10 ¾" (18cm x 27cm)  ※  Watercolor on paper

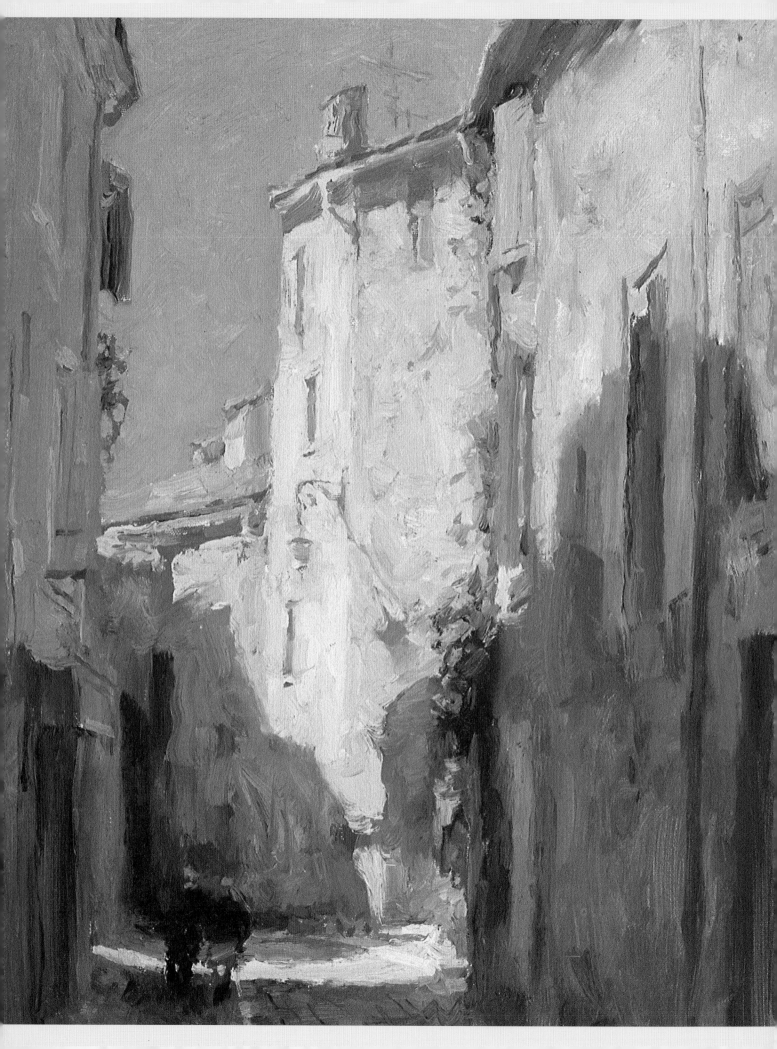

# color

There are many very effective systems for creating successful color schemes for your paintings—if you can remember them. Unfortunately, most are too complex to remember and too complicated to readily apply when you are locked in mortal combat with a painting in your studio or on location.

Although it might not seem obvious at first, the **ONE RULE OF COMPOSITION:** *Never make any two intervals the same* can be readily and usefully applied to color, coming to your rescue by simplifying color composition. The rule will help you add just enough

**variety** in the range of colors in your pictures

if you remember this formula: *Mostly, some and a bit.* When you apply this formula to the basic characteristics of color, you will almost automatically get a pleasing color scheme in your paintings.

● **Amour Doré** ❋ Kevin Macpherson ❋ 20" x 16" (51cm x 41cm) ❋ Oil on canvas

# characteristics of color

Artists usually describe color as having four characteristics: *hue, temperature, intensity* and *value*.

### Hue

*Hue* is simply the name or identity of the color used to distinguish one color from another.

YELLOW

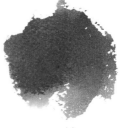

BLUE

RED

### Temperature

*Temperature* refers to color associations. Colors associated with heat and fire (reds, oranges, yellows) are called *warm colors*, and colors associated with ice and water (blues and greens) are called *cool colors*.

COOL COLORS

WARM COLORS

HIGH KEY

LOW KEY

### Intensity

*Intensity* refers to the purity or saturation of the color, or how close a pigment's color is to its pure spectrum color. Intensity is sometimes called *chroma* or *saturation*. A brilliant, clean color has high intensity; a grayed, dirty color has low intensity.

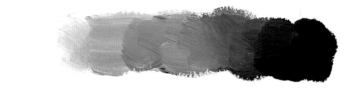

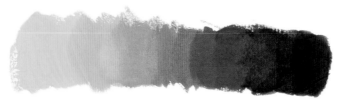

### Value

*Value*, or *tonal value*, is how light or dark the color is compared to a gray scale. Yellow is lighter in value than red. Red is lighter in value than purple.

# the color wheel

For our discussion, the basic and familiar color wheel contains the color relationships you need to know.

On the color wheel, the three *primary* colors (blue, red and yellow) are directly across from their *complementary* opposites (orange, green and purple). Orange, green and purple are also called *secondary* colors as they are each created by mixing two primaries.

Between each primary color and the secondary color is a *tertiary* color, such as yellow-green between yellow and green and yellow-orange between yellow and orange.

Colors close together on the color wheel (yellow-green, green and blue-green, for example) are called *analogous* colors.

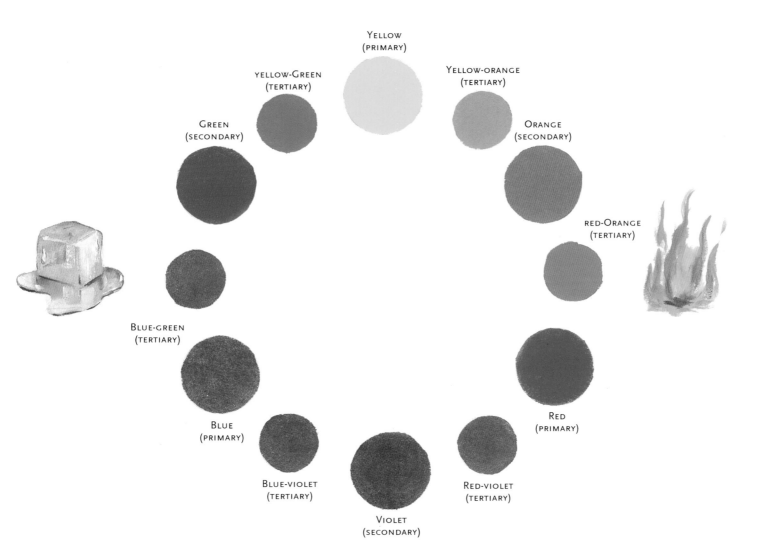

YELLOW
(PRIMARY)

YELLOW-GREEN
(TERTIARY)

YELLOW-ORANGE
(TERTIARY)

GREEN
(SECONDARY)

ORANGE
(SECONDARY)

RED-ORANGE
(TERTIARY)

BLUE-GREEN
(TERTIARY)

RED
(PRIMARY)

BLUE
(PRIMARY)

BLUE-VIOLET
(TERTIARY)

RED-VIOLET
(TERTIARY)

VIOLET
(SECONDARY)

# color dominance

The color wheel, or color spectrum, shown on *page 69* has all the colors in even amounts and in even increments. The change from one color to the next is the same for all colors. If a painting had every color of the spectrum in equal amounts, it would be chaotic. If a painting was done with only one color it would be unex-citing. There would be no pleasing variety in the proportions of colors in either case.

A handy way to achieve color variety is to remember this formula: *Mostly, some and a bit*. Your painting could be mostly one hue or family of analogous colors, with some of another color, and just a bit of a third contrasting color.

**Equal divisions of hues are boring**

**Unequal divisions of hues are more interest-ing**

**Mostly, some and a bit**
Blue is the dominant color in this composition. As shown in diagrams, the picture is mostly middle blue, some lighter, grayer blue, with a bit of warm color for contrast.

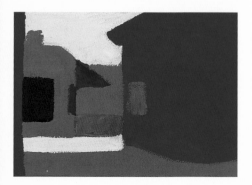

**End of the Line** ✳ James McFarlane ✳ 20" x 28" (51cm x 71cm) ✳ Watercolor on paper

# temperature dominance

When thinking about the colors of your composition, you don't even have to think about specific hues, only color temperature. To make your painting pleasing, you simply need to vary the quantities of warm and cool colors, so they are not equal. There should be either more cool colors than warm, or more warm colors than cool. You also need a touch or two of contrasting color (and value) to strengthen the center of interest. This color contrast becomes a natural focal point and should be located at your picture's center of interest. In other words, the colors should be mostly of one temperature, some of the other, and a bit of contrast.

If the dominant colors are warm, the composition will have an overall warm tone, and can be described as being *warm dominant*. If the dominant colors are cool, the composition is *cool dominant*.

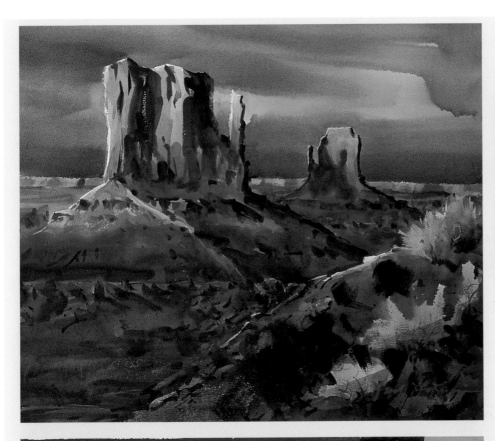

**Warm dominant**
This composition consists of mostly warm colors, including a warm violet, and therefore is warm dominant. There is some brown and a bit of orange.

**Sunset, Monument Valley** ✳ Frank LaLumia ✳
20" x 24" (51cm x 61cm) ✳ Watercolor on paper

# intensity dominance

The dominant and subdominant colors in your painting should not be of the same intensity or saturation. If both are pure, saturated colors, the painting will be harsh. If both are neutralized or grayed, the painting will be dull.

To maximize interest, you should use a range of color saturation. The colors should be neither all pure nor all gray. Save the pure, or high intensity, colors for the focal point.

The formula—*Mostly, some and a bit*—can be applied to all of the characteristics of color. Whether applied to hue, temperature or intensity (and value as will be seen shortly) the *Mostly, some and a bit* formula almost automatically guarantees a pleasing variety in your paintings.

In fact, if you only remember the *Mostly, some and a bit* formula when you paint, you will be following the **ONE RULE OF COMPOSITION**: *Never make any two intervals the same*. Either concepts will give you good results, and both are easy to remember and apply.

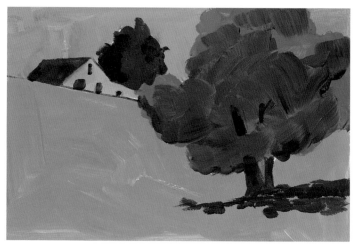

**Low-intensity, neutral colors**

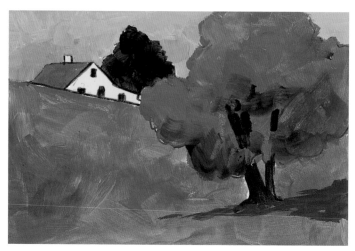

**Pure, right-out-of-the-tube, high-intensity colors**

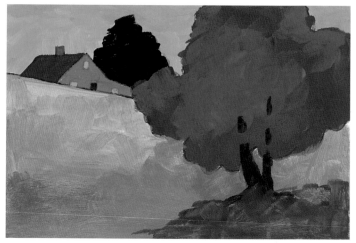

**A mix of pure and grayed (high and low-intensity) colors**

## Mostly pure color

This painting contains mostly vibrant, pure colors, with some neutralized colors and a bit of contrast at the focal point.

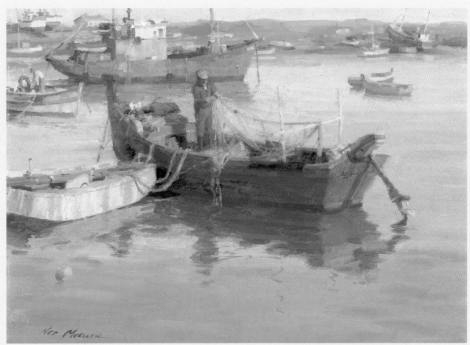

**Lagos Morning** ✳ Ned Mueller ✳ 12" x 16" (30cm x 41cm) ✳ Oil on canvas

## Mostly neutral color

In contrast to the painting above, this landscape has mostly grayed colors, with some brighter colors and a bit of value contrast.

**Winter Barn** ✳ J. Chris Morel ✳ 11" x 14" (28cm x 36cm) ✳ Oil on canvas

# value dominance

Value is more important to the success of your painting than color. Nevertheless, color is often what the viewers of your painting will notice most. Therefore, the value of your colors will be important in determining the success of your composition.

If the dominant colors of your composition are light in tonal value, the painting is said to be in a high key. If the dominant colors are dark in tonal value, the painting is said to be in a low key.

The dominant color and the subdominant color should differ in value for maximum effectiveness. If the dominant and subdominant colors are equal in tonal value, the painting won't have sufficient value contrast to maintain the viewer's interest. If both are dark or both light, the result will be boring.

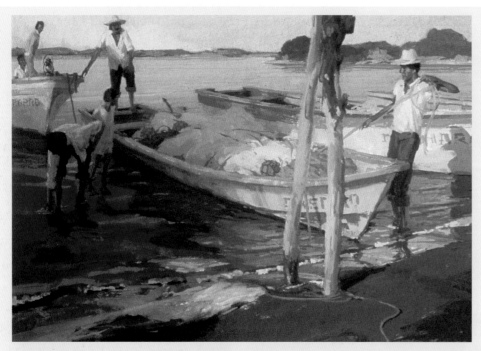

**Values of color**
Color is the most attractive quality of painting, but it is not always the most important. This artist has captured the warmth the setting sunlight by surrounding the sun-lit area with cooler, darker colors. Color and value work together to create the impression of late afternoon.

**Tying Up** ✳ Ned Mueller ✳ 10" x 13" (25cm x 33cm) ✳ Gouache on paper

**Color pattern simplified**
When simplified, you can see that the dominant colors are mostly cool.

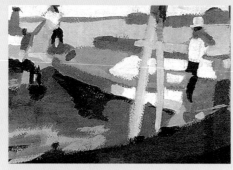

**Value pattern simplified**
When the colors in this painting are seen as values only, you can see that the values are mostly middle values with some dark and a bit of light. If the colors were all of the same value, the shapes in the picture would blend together when reduced to values only. (If your painting isn't too big, try taking it to a copy shop and making a black- and-white photocopy to see what the value scheme looks like; this can be an educational and humbling experience.)

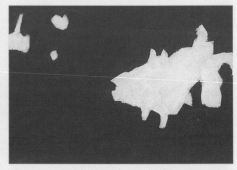

**Warm/cool and sunlight/shadow pattern simplified**
The warm colors are grouped in one area around the focal point, creating the effect of sunlight illuminating the center of interest as would a warm spotlight on a theater stage.

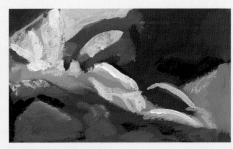

**Color pattern simplified**
The composition is made up of mostly cool colors, with some warm and a bit of contrast.

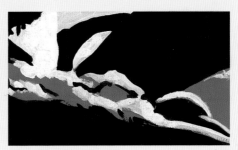

**Value pattern simplified**
This simplified value scheme shows mostly dark, some light, and a bit of middle values.

### A satisfying range of colors
This painting works well as a pure, almost abstract design. There is a very satisfying range of colors and values that attract, entertain and retain the viewer's attention.

**Morning at Rainbow Bridge** ✳ Gerald J. Fritzler, AWS ✳ 14" x 22" (36cm x 56cm) ✳ Watercolor on paper

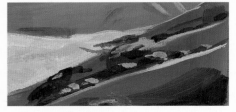

**Color pattern simplified**
The picture is built with mostly cool greens with some warm yellow-greens indicating those areas in sunlight.

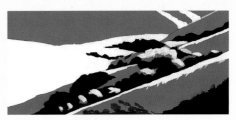

**Value pattern simplified**
This composition is mostly middle values with some light and a bit of dark.

### Even dramatic compositions retain simple value patterns
The dramatic diagonals of this painting make it a dynamic, eye-catching composition. Train your eyes to see through the details to the simpler pattern of values and colors underneath.

**La Cuesta Valley** ✳ Robert Reynolds ✳ 22" x 44" (56cm x 112cm) ✳ Acrylic on panel ✳ Private collection

# color contrast at the focal point

Landscape painters in the nineteenth century often included just one spot of red in an otherwise green landscape. The red was an *accent color* that made the greens look fresher and greener by contrast.

The accent color is sometimes called a *spice color* because, like a pinch of spice in a recipe that gives the whole meal a rich flavor, the accent color adds flavor and spark to your painting.

You can also call the accent color the *discord color*. It is a small discordant note in your painting, like a discordant note that wakes up the ear in a musical composition.

In your paintings, the accent color must contrast with

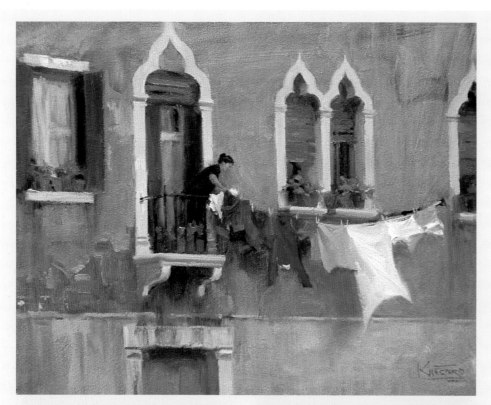

**Use color as the spice of your painting**
The *spice* in this painting is the wash being hung out to dry. The laundry is the focal point of the picture because that is where the brightest and most contrasting color is concentrated. Without this colorful accent, the picture would hardly retain the viewer's interest.

**Wash Day on the Campanile (Venice)** ✳ Robert Kuester ✳ 16" x 20" (41cm x 51cm) ✳ Oil on canvas

**Accent provides contrast at the focal point**
When the picture is simplified to its basic color components, you can see how color creates a magnet for the eye.

**No accent, no focal point**
When color and value are eliminated from the laundry, it loses its power to attract the eye, just as a spice that has lost its flavor would not enhance the flavor of a dull meal.

both the dominant and subordinate colors. The contrast can be in value or temperature, or a combination of the two. If the overall value key of a painting is low (that is, mostly darks) the accent should be light; if the value key is high (that is, mostly lights) the accent should be dark. If a composition has a color scheme that is predomi-nantly warm, the accent should be cool; if the color scheme is cool, the accent should be warm.

### Use color boldly

There is no doubt what the center of interest is in this picture! Color is used boldly to make the solitary bird the focal point amidst the autumn foliage.

**Autumn Red** ✳ Rod Lawrence ✳ 9" x 14" (23cm x 36cm) ✳ Acrylic on panel ✳ Private collection

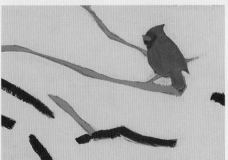

### Accent provides contrast at the focal point

Like a single bell heard on a quiet morning, the one note of red attracts attention immediately. (Notice that it is placed in one of the sweet spots.)

### No accent, no focal point

When the bright red is replaced with a dull color, the bird gets lost in the leaves and the whole picture becomes uninteresting.

# still lifes

The still life is a genre with a long and honorable tradition; contemporary still life has its roots in Dutch painting of the seventeenth century. The traditional still life usually features a tabletop arrangement of flowers, fruit, food and various kitchen or household items, including personal effects. Often, still lifes have been interpreted as

**celebrations** of mundane pleasures,

or as reflections on the transitory nature of life.

Still lifes offer many opportunities to apply the **ONE RULE OF COMPOSITION:** *Never make any two intervals the same* because you have a lot of choices for subject matter and composition. You choose the objects to be painted, you arrange these objects the way you want, and you control the lighting and the background. With each choice, the **One Rule** can be a guide that will help you make better paintings.

● **Five Yellow Peonies**  ※  Kurt Anderson  ※  24" x 18" (61cm x 46cm)  ※  Oil on canvas

chapter 7

# selecting your still life subjects

Common still life objects include flowers in all sorts of containers, wine bottles or other containers, fruit such as apples, pears and grapes and objects such as small figurines, clocks, books and other common household items. Albeit a tired cliché, still lifes composed of these objects are still popular and are often presented to students in painting classes, so let's play with these items while applying the **ONE RULE OF COMPOSITION**.

When making your selection of objects, you should avoid too many objects that have boring shapes or similar sizes. Anything square, round or equilateral (the boring shapes mentioned in *chapter 2*) should be chosen carefully. Too many round apples all of the same shape, size and color present a challenge merely because they are too much alike. However, by remembering the **ONE RULE OF COMPOSITION** and varying the distances and groupings among the objects, we can make an interesting arrangement even out of objects of the same size.

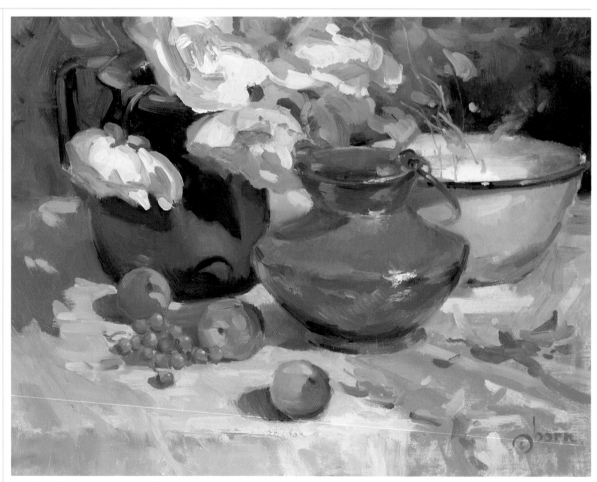

**A variety of objects create a satisfying composition**
Only a small number of objects are needed for an effective still life composition when those objects vary in size, shape, color and textural detail. This still life contains about a dozen objects (not counting every flower or grape) that exhibit a wide variation in characteristics. For example, the three containers consist of a large, dark blue pitcher, a white enamel bowl and a copper pot. These objects vary in color temperature, size, shape and surface quality, ensuring that there will be satisfying contrasts in any arrangement containing them.

**#1** ※ Anne Marie Oborn ※ 20" x 24" (51cm x 61cm) ※ Oil on canvas

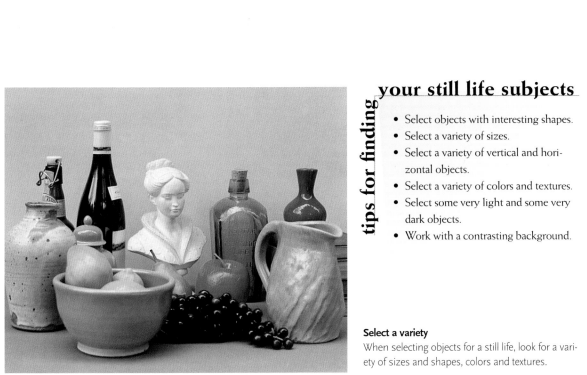

# tips for finding your still life subjects

- Select objects with interesting shapes.
- Select a variety of sizes.
- Select a variety of vertical and horizontal objects.
- Select a variety of colors and textures.
- Select some very light and some very dark objects.
- Work with a contrasting background.

**Select a variety**
When selecting objects for a still life, look for a variety of sizes and shapes, colors and textures.

**Too many similarities here**
These objects are all roughly the same size and have rather symmetrical, boring shapes. Even the grapes form a regular triangle. Combine objects like this with objects that contrast in size, shape and texture.

**Good variety here**
These objects differ in size, shape, color and texture. It would be possible to make an interesting arrangement with these three objects alone.

# arranging a still life

When arranging still life objects, observe the **ONE RULE OF COMPOSITION**. Look at what shapes are created and the larger configuration the objects form when grouped together. Place the objects in asymmetrical groups.

create a still-life

## composition laboratory

The examples on these pages were made with simple shapes cut from colored or painted paper. To quickly experiment with different arrangements, you can make your own still life composition laboratory with scissors, an assortment of light and dark colored paper and a glue stick. A pair of cardboard *ells* as described in *chapter 8* are handy for playing with optional ways of framing or cropping.

Working with paper cutouts allows you to make very subtle adjustments of placement before fixing anything in place permanently. Working this way encourages you to think in terms of basic shapes, colors and values without the distraction of detail and texture. A lot can be learned in a short amount of time. Just keep the **ONE RULE OF COMPOSITION** in mind as you play with the shapes.

**Diagonal division of space is boring**
Don't inadvertently line up objects to create a diagonal division of space, a boring partition of the composition.

**Objects that parallel the frame are boring**
Avoid placing things parallel to the picture frame. In this example, the wine bottle is too close to the edge and parallel to it, creating a boring strip of space along that edge. The arrangement is also unbalanced, with the visual weight to the left, leaving a dull expanse of space in the upper right.

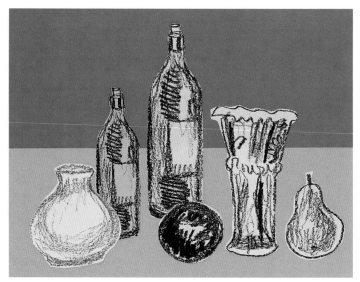

**A symmetrical triangle is boring**
Don't pile objects up in a symmetrical or equilateral triangle. Placing a single tall object in the middle divides the picture into two equal (and therefore, boring) halves. This arrangement is inherently static and uninteresting.

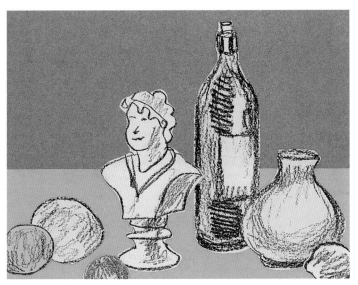

**Better, but still too parallel**
Arranging objects in an irregular triangle is often a good strategy because there is an uneven number of sides. However, avoid making any one side of the triangular arrangement parallel to the side of the picture frame because the intervals thus generated are too much the same.

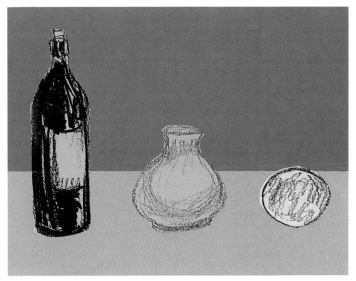

**Equal spacing is boring**
Talk about dull! Don't line up objects so they are equally spaced, from each other or from an edge, as in this case where all the objects are the same distance from the bottom—boring!

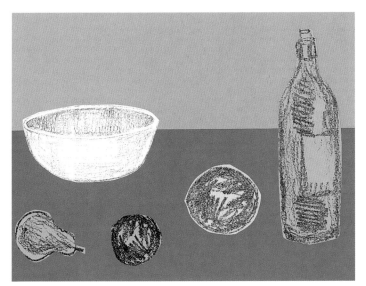

**Lack of depth is boring**
Overlapping creates depth. When objects are equally spaced with no overlap, the viewer has no clues to the space they occupy.

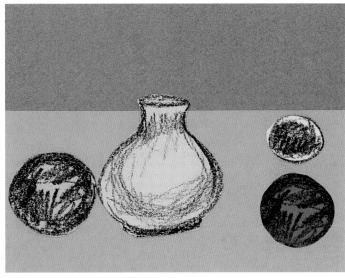

**Objects in a row are boring**
Don't place an object so it appears directly above another object. Such an arrangement is confusing, boring and often flat. Better to relate the objects on an oblique. Don't let objects touch on a single tangent point.

# dynamic balance

When assembling a still life, you have almost complete freedom to select and arrange the setup into a visually appealing configuration. Because many common still life objects such as fruit, cups, glasses or other tabletop items are similar in size and visual weight, look for as many ways as possible to apply the **ONE RULE OF COMPOSITION** to make it interesting. Vary the placement of objects to avoid forming boring shapes or configurations.

Avoid symmetrical arrangements centered in the format. Some common still life objects, such as flowers in

**Objects in symmetrical arrangement**
This is an extreme example of a symmetrically balanced composition. The visual weight and energy are equally divided on either side of a central vertical axis.

**Objects in asymmetrical arrangement**
In contrast, this arrangement is dynamically balanced, with the introduction of as much variety in placement, size and shape as possible.

a vase, tend to be naturally symmetrical. Look for ways to create a dynamic balance by shifting the center of gravity off-center. Exercise creative license and vary the shapes so there is a pleasing irregularity.

### Symmetrical objects in an asymmetrical arrangement create interest

Most of the objects in this still life are symmetrical, but they are arranged so they do not form a symmetrical pattern. The bright and visually energetic leaves of the poinsettia function as the dominant focal point, nicely offset in one of the sweet spots.

**Christmas Still Life** ⁕ Tom Browning ⁕ 20" x 24" (51cm x 61cm) ⁕ Oil on canvas

### Symmetrical arrangement is static

When the picture is truncated so the poinsettia is in the center, the resulting composition is static and undynamic.

# simplicity

Don't crowd too many objects into your still-life arrangements. Often a few objects are better than many. Too many objects competing for attention makes it difficult to establish a strong center of interest, especially if many of the objects are similar in shape and size. A few objects varying in size, shape, color and texture that have been carefully but dynamically balanced can create a very compelling arrangement.

**Subtle variations establish the mood**
You don't need many objects to make an effective still life composition. Marion's *Santa Fe Irises* has only seven objects, counting the two flowers. The pattern of the light through the window on the curtain and wall and the softness of the shadows give the picture a warm, inviting and optimistic impression.

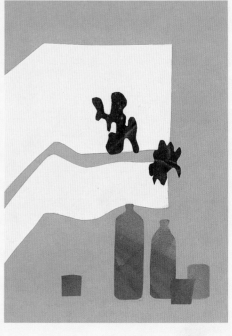

**Santa Fe Irises** ✳ Marion Welch ✳ 28" x 20" (71cm x 51cm) ✳ Watercolor on paper

Experiment with arranging a small number of objects. See how few are needed to make an interesting composition. Can you create an arresting arrangement with only seven or five objects? Try working with only three objects, one large, one small and one in between, that vary in color and shape.

### Interesting shapes create variety

Janie Gildow has used only three pears, dramatically lit, to fashion a powerful and compelling image. This is certainly an example of when less is more! The picture is based on strong value contrast that arrests the eye. Simple does not mean boring.

**Shadow Still Life, No. 1** ✳ Janie Gildow, CPSA ✳
11" x 15" (28cm x 38cm) ✳ Colored pencil on paper

# making compositional choices

A good composition, be it still life or any other genre, is the product of a series of decisions. Ideally, each decision should be consciously made by the artist, based on informed deliberation. All too often, beginners start working without thinking things through, going by habit or convention. The framing or cropping of the shapes in your composition should be consciously chosen from the beginning.

**Simple, pleasing composition**
The five objects form an interesting, irregular shape. The center of visual gravity of the grouping is located at one of the sweet spots. The center of interest includes the head of the statue and the neck of the wine bottle. There are no two intervals that are the same.

**Weak composition**
The white statue is too close to the center of the design, with objects of equal weight on either side, forming a regular (boring) triangle. The green bottle on the left is the same size as the gray vase on the right and both are located the same distance from the nearest side.

**Acceptable composition**
The flowers and the bust are too similar in size, so they compete for attention. The lime and the orange are related vertically, an awkward placement. Through the use of artistic license, you can adjust one of the objects to be more dominant.

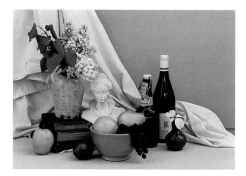

**Unbalanced arrangement**
The arrangement is weighted on the left, with a vacant space in the upper right corner. The composition is crowded with too many objects of similar visual weight, so they are competing for the viewer's attention.

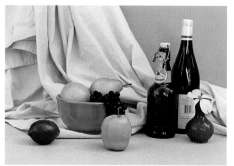

**Well-balanced arrangement**
The triangular shape of the objects seen as a group is countered by the oblique thrust of the background drapery. The center of interest is formed by the bottles on the left. The tall wine bottle and the bottom of the drapery align with the perpendiculars determined by the **Rule of Thirds**. One improvement would be to rearrange the lime, lemon and small red vase on the right so the intervals between them are not equal.

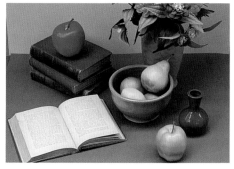

**Vantage point makes a difference**
The unusually high vantage point of this composition makes one uneasy because it isn't clear where the viewer could be standing.

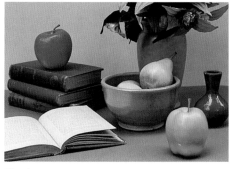

**Pleasing arrangement**
This composition exhibits a more natural viewpoint. The objects are irregularly spaced from each other and the edges of the frame. Together, the objects form an interesting shape.

## Choosing variety

The doll is the primary center of interest. It is located in one of the sweet spots identified by the **Rule of Thirds**. The colors are mostly warm, mid-value colors, with some darker and cooler colors (the blue basket) and a bit of bright contrast in the yellow roses. There is enough variety in placement, shape and texture of the objects to make this picture one you could live with for a long time.

**Yellow Roses With Japanese Doll**
❋ Robert A. Johnson ❋ 11" x 14" (28cm x 36cm)
❋ Oil on canvas

## Choosing dynamic balance

This composition is also dynamically balanced. The primary area of interest—the porcelain jar, blue pot and peony—is in the right center, counterbalanced by the green jar and roses on the left. Because the porcelain jar is set against the deep, dark background, and the peony is set against the dark blue pot, the resulting contrasts attract the eye and form a strong anchoring point as the viewer explores the rest of the picture.

**Old Lace and Colored Glass** ❋ Robert Kuester ❋
30" x 40" (76cm x 102cm) ❋ Oil on canvas

# choosing textures

This watercolor still life is a study in textures as revealed in the glow of a single light source. The warm colors throughout are appropriate for the autumnal theme.

**Fall Arrangement** ❉ Michael P. Rocco, AWS ❉
14" x 21" (36cm x 53cm) ❉ Watercolor on paper

**Value and shape study**
When you examine a painting not in terms of the shapes, but as a pattern of value shapes, you can judge more easily if a composition "works." This painting contains mostly dark shapes, some mid-value shapes, and bits of light shapes.

**Value study**
Because it exhibits the composition's sharpest contrast between light and dark, the pumpkin stem becomes the picture's center of interest. In addition, the light directs the eye to focus on this spot.

# choosing varied intervals

This beautifully painted still life complies with the **One Rule of Composition** in almost every aspect. No two intervals of distance, shape, dimension or size are the same, and if the color wheel and the tonal value scale are thought of as ranges with intervals, these elements comply too.

Most of the colors in the picture are cool or neutral, with the exception of the red berries. The white flowers and the red berries are the primary and secondary focal points, both located at sweet spots according to the **Rule of Thirds**.

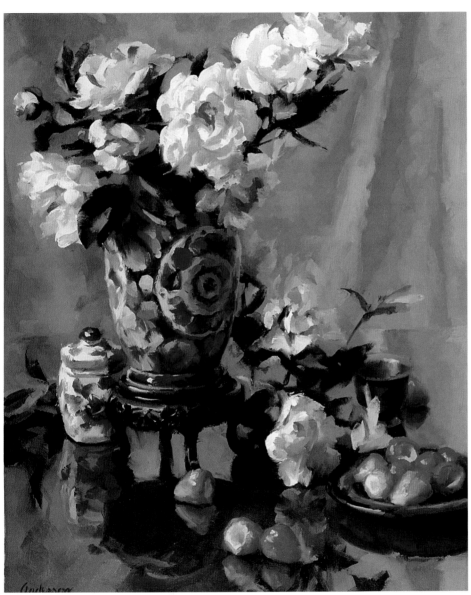

**The Indigo Vase** ❋ Kurt Anderson ❋ 30" x 24"
(76cm x 61cm) ❋ Oil on canvas

**Value study**
The lights and darks are arranged in an eye-pleasing, irregular pattern made up of mostly middle values, some darks and a few whites.

**Underlying shape**
When reduced to a simple sketch, objects in the painting form an aggregate shape that is interesting to the eye.

# landscapes

Nature rarely supplies us with perfect compositions. As artists, it's our privilege (or duty) to improve on nature.

Rather than produce an exact copy of what we see before us, we need to adjust the composition to make a more interesting painting. This is an advantage painters have over photographers: the photographer does not have the ability to move a few trees around in his viewfinder, but the painter can add, move or eliminate trees, buildings and clouds if it will make a better picture.

As artists, we can **rearrange** landscapes to comply with the **ONE RULE OF COMPOSITION:** *Never make any two intervals the same.*

The time to make decisions about how to improve on nature is before you start to paint. Use your sketchbook to make a preliminary study of both the placement of elements in your painting and the overall value pattern. Once you have started to paint, making changes becomes harder and your willingness to do them decreases. Better to plan your composition before you begin to put paint on paper or canvas.

# make use of photographs

A great way to practice applying the **ONE RULE OF COMPOSITION** to landscapes is to use photographs and an adjustable composition finder made up of two cardboard *ells*. Most artists take advantage of photographic sources for information for their studio work. Time is often too limited to allow for recording all we need to paint from in a sketchbook alone.

Back in the studio, use photographic references judiciously lest they become a hindrance to your progress as a painter. Simply copying from a photo teaches you little and renders disappointing results.

## Use your own photos

If you use your own work to begin with, you won't be tempted to plagiarize. This exercise will make you a much better photographer because you'll quickly see how to improve your photos while you are looking through the viewfinder. Because you are using images

**try different ways to**

## frame your subject

- Are there any lines or edges that divide the picture in half or in equal units?
- Does your picture have a primary center of interest?
- Is the center of interest also a strong focal point?
- Is the center of interest at a sweet spot?
- Are there any lines that lead the eye out of the picture?
- Are there strong value contrasts in your picture?
- Are the shapes in your pictures interesting?
- Are there any strong obliques?

**Two cardboard ells**
Make two ells out of black cardboard or poster board. Use a ruler or protractor to get reasonably accurate right angles. Cut the ells 2½" (6cm) wide, with each leg about 10" (25cm) long.

**The two ells clipped**
Paperclip two homemade ells together to make an adjustable frame for finding the best composition on a snapshot.

**The two ells on top of a photograph**
Use the ells to frame your photographs in various ways. Snapshots are fine; no fancy cameras or equipment are needed. Experiment with different placements of the frames to find the most interesting composition. You'll probably find several that work well. Keep adjusting the ells to find the best (that is, most interesting) placement of lines or objects in the picture. Make a quick sketch of the ones you like.

that you found personally attractive in the first place, you'll find working with them more interesting and the results will be uniquely your own.

### Transfer your composition

Make sketches of the compositions you have framed with the ells, or paperclip the ells to the pictures and use them to make a sketch on the canvas. If you get double prints when you have your film developed, you can take a black marker and mark right on the photo for later reference, or use scissors or a paper cutter to trim the photos down.

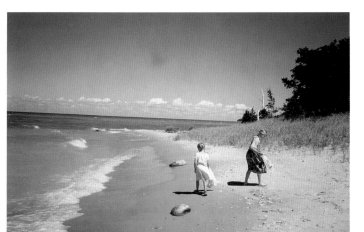

**Reference photo**
This lakeside scene was snapped while on vacation using an inexpensive 35mm camera with a zoom lens. As is often the case with spur-of-the-moment shots, there was little time for planning, especially since the figures were moving. However, the picture caught the light and mood, as well as plenty of information to paint from in the studio.

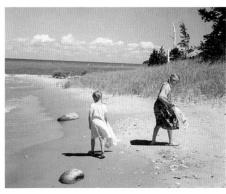

**Bad crop**
An almost-square format is awkward because it makes it difficult for the artist to avoid equal intervals. In this framing, the figure on the right is in the center, while the figure on the left is too close to the left edge. The figure on the left is also looking out of the frame, which directs attention out of the picture. Also, the picture does not show enough of the beach to establish the locale.

**OK crop**
The figures are still somewhat centrally located, but there is a more dynamic relationship between them and the edges. The figures are large enough to balance the space they are in. Also, the diagonal lines in the background generate enough excitement to make this composition acceptable.

**Best crop**
Both figures are now placed so the distances between them and the four edges are all unequal. The horizon line is comfortably off-center. The diagonal lines in the background are interesting and do not run into the corners. The girl on the left is the primary focal point because of the contrast between her skirt and the sand. The white tree trunk directly above her head should be moved to either side so it is not related to the figure vertically.

# an alphabet of landscape composition

An easy way to remember some handy patterns for your landscape compositions is to think of composition based on letter forms. Almost any letter form can be the basis for a good design if you remember to apply the **ONE RULE OF COMPOSITION**. However, the most useful letters are *J, O, T, X, C, L, U,* and *S.*

### J Composition

Think of this as a lazy *J* or swoosh that can appear as shown, backward and upside down. The curved bowl of the *J* is a good place for the center of interest. Here, the bowl is located at one of the sweet spots.

### O Composition

This composition is more or less circular, but not centered exactly in the middle of the painting rectangle.

### T Composition

A vertical and horizontal crossing in a composition creates a natural focal point at the point of intersection. The quadrants created by the crossing should vary in dimension to maximize visual interest.

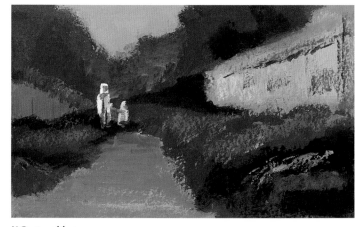

### X Composition

Compositions based on the letter *X* include those that have lines radiating from a single point. Make sure that linear elements radiating outward do not go directly into a corner, forming in effect an invitation for the viewer's eye to exit the picture.

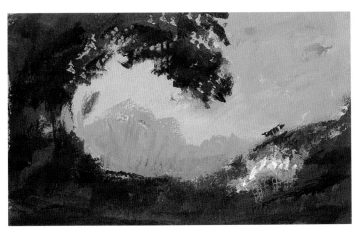

**C Composition**

The letter *C* can be thought of as a half or open *O*. Don't situate the opening right at the center.

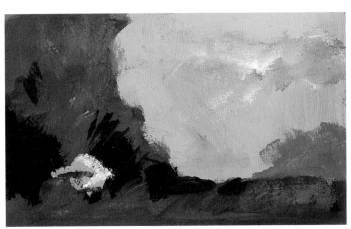

**L Composition**

The *L* can be turned around or upside down. It's important to keep one side of the *L* longer than the other. Equal lengths would be boring.

**U Composition**

The uprights of the letter *U* (or *V*) can be used to frame a center of interest. Be careful, however, to avoid making both sides equal, which is boring. Make one side larger, more dominant or dynamically balanced than the other.

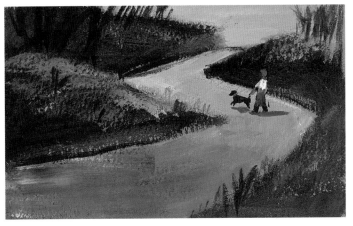

**S Composition**

The letter *S*, as written or as its mirror image, is a natural lead into a composition. The classic example is a road curving into the picture.

# basic value patterns for landscapes

A successful landscape, like all good compositions, will be based on a strong pattern of values. Because nature doesn't always present us with easy-to-recognize patterns, it helps to know what to look for. Look for patterns based on the alphabet of landscape compositions (*see previous pages*), which are all based on strong shapes of contrasting tonal values. Contrast and variation are the inevitable products of the application of the **One Rule**: *Never make any two intervals the same.*

Tony Couch, a well-known contemporary watercolorist and master of applying the rules of design to create effective composition, noted in his best-selling book, *Watercolor: You Can Do It!* (North Light Books, 1987), some very useful value patterns for landscape composition.

**Creating areas of value contrast**

Couch identified six basic patterns for landscapes (*see art below*). These patterns help you simplify a landscape into three distinct areas of value contrast. Each has three grounds: foreground, middle ground and background.

- Two have light foregrounds, two have light middle grounds and two have light backgrounds.
- Two have mid-value foregrounds, two have mid-value middle grounds and two have mid-value backgrounds.
- Two have dark foregrounds, two have dark middle grounds and two have dark backgrounds.

Dark foreground, mid-value middle ground and light background.

Dark foreground, light middle ground and mid-value background.

Light foreground, mid-value middle ground and dark background.

Light foreground, dark middle ground and mid-value background.

Mid-value foreground, dark middle ground and light background.

Mid-value foreground, light middle ground and dark background.

## Contrast values using large and small shapes

Couch also identified two other useful value patterns that are almost guaranteed to produce successful compositions. These are similar to the patterns shown in *chapter 2*. Both patterns include a large shape against a mid-value background. In one, the large shape is dark; in the other, it is light. Inside both is a much smaller shape in contrasting value. This contrasting shape is a natural focal point. These patterns fit the **ONE RULE OF COMPOSITION**: *Never make any two intervals the same.* The large shape and small shapes against the even larger mid-value background automatically create a pleasing variety of shapes and values. These sets of patterns are worth remembering because they ensure an interesting composition. The trick to using them is to do a thumbnail sketch of your painting or drawing no larger than a post card. It can be a simple line drawing or a gestural scribble. You must fill in the tonal values; don't rely on your imagination or memory.

**Maui** ✳ Frank LaLumia ✳ 22" x 30" (56cm x 76cm) ✳ Watercolor on paper

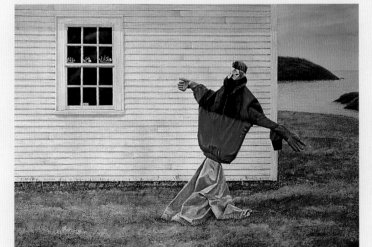

**Island Scarecrow** ✳ James Dean ✳ 22" x 30" (56cm x 76cm)
✳ Gouache on paper

### Dark on middle value

This painting is built on the pattern of dark shape (the rocks) on a mid-value background (the foliage), with a light shape (the waterfall). This painting fits our *Mostly, some and a bit* formula: it is mostly mid-value, some dark and a bit of light.

### Light on middle value

This painting is built on a large light shape on a smaller mid-value background, with several spots of dark. The pattern is mostly light, some mid-value and bits of dark. If you made a three-step value scale with only black, gray and white in the same proportions, as in either painting on this page, you would see that the intervals dividing the value steps would not be the same.

# perspective

Perspective used well will give your pictures a convincing sense of depth and enhance their believability. Proper perspective is important if your goal is pictorial realism. Inaccurate perspective will make your paintings "look wrong."

Perspective can also be used to enhance the composition of your paintings. It can be used to create pointers that will guide the viewer's eye along a path of your design. Perspective can be used to pull the viewer into the picture or point the eye toward a particular element.

The illusion that objects of the same size appear smaller as their distance from the observer increases makes linear perspective an ally in our efforts to create variety in a painting. For example, railroad rails are parallel; the interval between them is predictably the same. When seen in perspective, however, these rails no longer appear parallel, but appear to converge on the horizon. The interval appears to diminish, attracting the eye. Likewise, telephone poles in a row are at equal intervals, but perspective makes them appear closer together and smaller as they recede.

## Atmospheric perspective

Not all perspective is linear. Atmospheric perspective contributes to the sense of depth or distance in a picture by suggesting the presence of intervening atmosphere

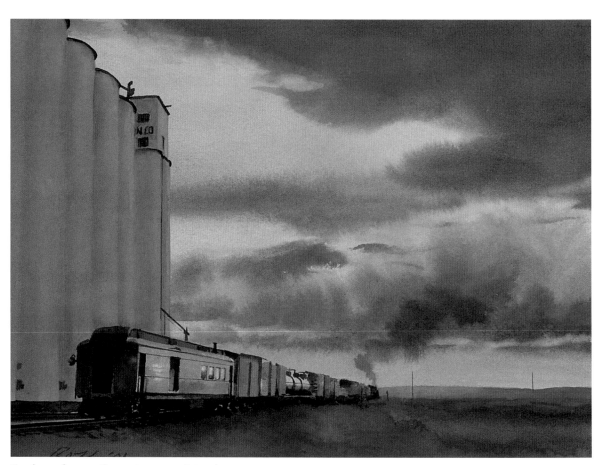

**Good use of perspective creates uneven intervals**
The eye is pulled toward the horizon line by the train, with the distant plume of smoke as an anchor. The vanishing point (that point at which the parallel lines appear to converge) is more interesting compositionally when it is offset from the center of the painting. By placing it off-center, near one of the sweet spots, you'll create intervals that are more irregular and more interesting.

**Markers** ❋ Ted Rose ❋ 12" x 16" (30cm x 41cm) ❋ Watercolor on paper ❋ Collection of Dr. Jay Caldwell

between the foreground and distant background. Distant objects in a landscape will often appear cooler in color temperature and with less tonal contrast because of the dust or moisture particles suspended in the air. Atmospheric perspective can be used to keep distant things from competing with the center of interest because detail, color intensity and tonal contrast will be greatly reduced. As noted in *chapter 7*, sharp detail, defined edges, bright color, strong tonal contrast and rich texture are all things that make a center of interest or eye magnet, and are the very things obscured by atmospheric perspective.

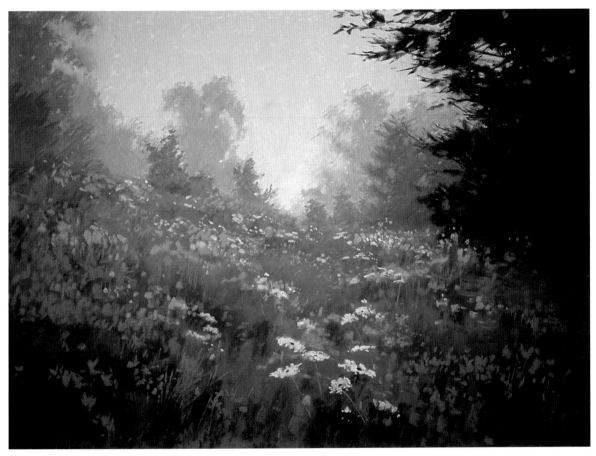

**Distance can help establish uneven intervals**
Atmospheric perspective produces depth in a picture by suggesting the presence of intervening atmosphere between near and distant objects. Here, the background trees have been neutralized in color and value to suggest distance.

**Summer Wildflowers** ❋ Elizabeth Mowry ❋ 18" x 24" (46cm x 61cm) ❋ Pastel on paper

# color in landscapes

When applied to color, the *Mostly, some and a bit* formula almost automatically creates a color scheme that complies with the **ONE RULE OF COMPOSITION**. If the colors in a landscape are distributed equally, that is, if there are equal quantities of warm and cool colors, light and dark colors, pure and neutralized colors and so on, there will be no dominance and no variety—and therefore, no interest for the viewer.

## keep an eye on color

All the color theory in the world won't help if you can't remember it! Think: *Mostly, some and a bit* and your paintings will have a satisfying color scheme.

- Is your landscape mostly warm or mostly cool?
- Is it mostly dark or light?
- Do some of the colors and values contrast sufficiently with the dominant colors and values to create interest?
- Is there just a bit of strong contrast to make one part of the picture a good focal point or center of interest?

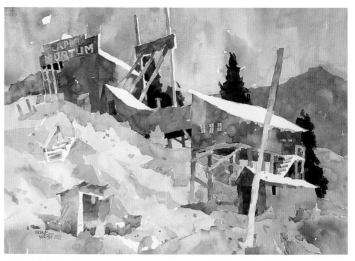

**Follow the formula**

Frank's painting is a good example of the *Mostly, some and a bit* distribution of color in a landscape. The picture is mostly cooler pastel colors, with some rich, bright blues in the mine buildings, with a bit of dark green in the trees for a contrasting accent.

**Gold Mine** ❋ Frank Webb ❋ 22" x 30" (56cm x 76cm) ❋ Watercolor on paper

**A bit of contrast**

This low-key painting features dominant colors that are dark and cool. In sharp contrast are the bold strokes of almost pure orange and red on the hull of the ship on the right and in its reflection, as well as the bright whites nearby. These strokes form a strong focal point, located at one of the sweet spots.

**The Mimi and the Rana** ❋ C.W. Mundy ❋ 16" x 20" (41cm x 51cm) ❋ Oil on canvas

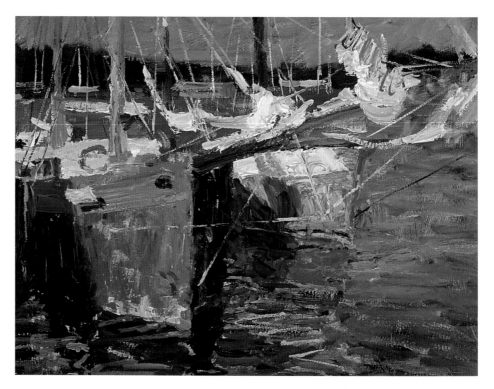

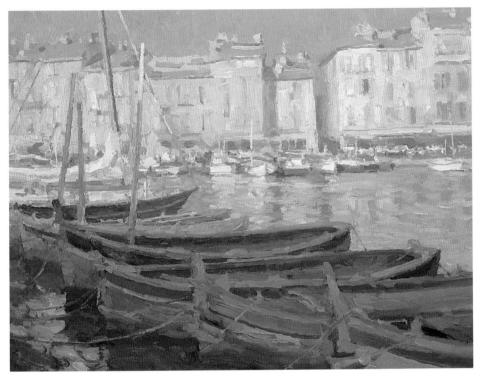

### Variety attracts the eye

A cool, dark foreground against a warm, light background forms the underlying color structure of Kevin's painting. The eye is naturally attracted to the sunlit building along the waterfront, but the strokes of rich color on the foreground boats balance them nicely. If the colors were either all bright or all dark, or all cool or all warm, the eye quickly would become fatigued and would seek relief outside the composition.

**Cast Shadows of Cassis** ❋ Kevin Macpherson
❋ 16" x 20" (41cm x 51cm) ❋ Oil on canvas

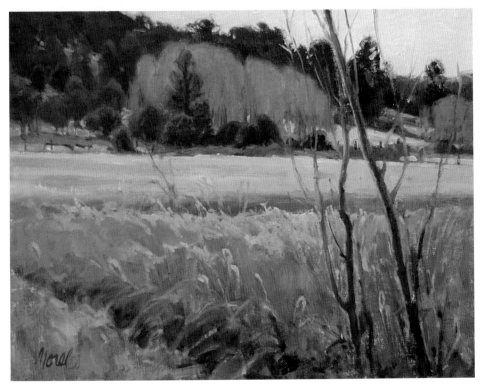

### Value and texture entertain the eye

Colors in a landscape don't have to be intense to be effective. This painting employs a subtle scheme that relies on value and texture as well as color to entertain the eye. The foreground is cooler and darker at the bottom and gets brighter and warmer toward the middle ground, carrying the eye to the dark greens that frame the aspen cluster in the background. The painting is divided by the dark edge of the background, and the narrow tree trunks on the right align almost exactly according to the **Rule of Thirds**.

**Aspen Cluster** ❋ J. Chris Morel ❋ 11" x 14"
(28cm x 36cm) ❋ Oil on linen

# *figures and* portraits

The human figure is the most enduring subject for artists since humankind first painted on cave walls. The body is capable of marvelous agility, articulation and expression, and is an engaging challenge for artists.

The appeal of the human form is its **grace**, fascinating complexity and infinite variation. In particular, the body exhibits a dynamic balance that makes it a perfect subject for artistic composition. This chapter focuses on applying the **ONE RULE OF COMPOSITION:** *Never make any two intervals the same* when working with people as the primary subject.

● **Blue Stockings** ✳ Joan Rudman, AWS ✳ 28" x 22" (71cm x 56cm) ✳ Watercolor on paper

# placing the head

The **ONE RULE OF COMPOSITION** tells us not to place the center of the head so it is in the exact center of the picture, especially if the head is facing straight out. Place the head and face in one of the upper sweet spots. If the head is near the center, use areas of lights and darks in the background to alleviate the static formality of this kind of placement.

With a three-quarter view, allow more space on the side to which the face appears to be looking to avoid a claustrophobic closeness and give the subject room to breathe. In general, don't let the top or back of the head form a tangent with the edges of the picture.

**Boring composition**
The head is exactly centered and looking straight toward the viewer. The distance of the face from top to bottom and side to side is equal.

**Better composition**
When the head is off-center from both top to bottom, the portrait is more intriguing. The center of the face (both focal point and center of interest) is now located in a sweet spot.

**Good composition**
With a three-quarter view, the center of interest is right between the eyes at one of the sweet spots.

**Boring composition**
This profile is centered and boring. Eye level is near the horizontal center. The face appears cramped by the right edge, and the subject's eye directs your attention to and beyond the frame.

**Better composition**
This profile is off-centered and more interesting. There is more room to breathe on the right, so it feels less cramped.

**Good close-up composition**
This profile is cropped close-up, which generates some interesting abstract shapes. The eye is now in a sweet spot.

### A closely cropped portrait generates intensity

This close-up profile draws your attention to the character of the man as revealed in the details of his face. Closely cropped closeups provide an intense encounter with an individual. The sharp contrast of face against background arrests your eye and creates a strong focal point.

**Leonard** ✳ Dee Knott, AWS ✳ 20" x 28" (51cm x 71cm) ✳ Watercolor on paper

### Draw attention to your subject's face

By minimizing any background detail, the artist concentrates your focus on the face and its intent gaze. You see enough of the hat and clothing to garner important clues about the subject.

**Mr. Hamm** ✳ Dee Knott, AWS ✳ 18" x 24" (46cm x 61cm) ✳ Watercolor on paper

### Position your subject to lead the viewer's eye

The head is located at the crossing of the walls change in value and texture and at the apex of the triangular mass of the man's body. The artist has included a lot of space on the right for the figure to look into, inviting the viewer to imagine what is beyond.

**Patrick** ✳ Dee Knott, AWS ✳ 20" x 28" (51cm x 71cm) ✳ Watercolor on paper

# placing the head and upper body

When including the head and torso, again place the face in one of the sweet spots, with the face toward the center and the rest of the body dynamically balanced with the edges.

Avoid placing the head in the center, especially if it places the rest of the body in an unbalanced position to one side.

Wherever the head is placed, avoid any element that is crowded in or points to one of the lower corners.

The hands will be a natural secondary focal point, so check to see that they are at varying intervals from the edges. Also, beware of awkward cropping, especially at any body joint such as a the elbow, knee or hands.

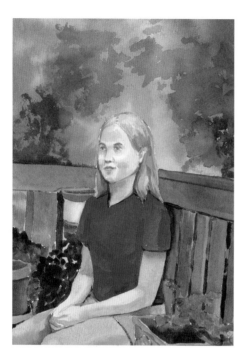

**Bad composition**

When including the head and shoulders of your sitter, place the head near one of the upper sweet spots. Placing the face in the exact center will usually leave dead space above the head. In this example, the knees not only point into the corner, but are awkwardly amputated.

**Bad composition**
The head is located in a sweet spot, but the composition is unbalanced because the subject is looking out of the picture, making the right half appear dead.

**Good composition**
The head is located in a sweet spot, but the picture looks balanced because the subject is looking toward the center, activating that part of the composition.

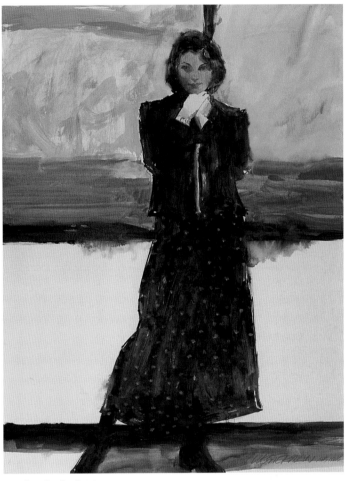

**Head as the center of interest**

There is no doubt about the center of interest in this portrait. The mind is naturally attracted to heads and faces. The head is located in the upper-right sweet spot, and is looking out to the right. To keep the viewer's eye from wandering off to the right, the artist has strategically placed the darkest shapes in this location as a block.

**Caroline** ✳ William H. Condit ✳ 14" x 21" (36cm x 56cm) ✳ Watercolor on paper

**Head as the focal point**

Strong value contrasts and rich texture make the head the dominant focal point, with the hands as a secondary focal point. The eye is naturally attracted to strong contrast. The background and clothing almost merge into one dark shape. This is a good example of a dynamic balance between the relative amounts of dark and light values.

**Tribute to Mondrian** ✳ Arne Westerman ✳ 29" x 21" (74cm x 53cm) ✳ Watercolor on paper

# placing the figure

When depicting the figure, consider its shape in relation to the edges. Placing the figure so there are wide margins between it and the edges of the format generates little compositional interest. Distances between various parts of the figure and the frame are not dramatically different and therefore boring.

When the figure is enlarged so it fills the frame, or the edges are cropped more closely to the figure, the relative distances from figure to frame are more varied and, for that reason, more interesting.

**Lots of background, no interest**
When there is a lot of room between the shape of the figure and the edges, there is little compositional interest.

**Tangents identified**
Avoid awkward tangents. Body parts just touching an edge will attract unwanted attention.

**Tight cropping, more interest**
Tight cropping is more interesting because the resulting intervals differ greatly in measurement.

**Background shapes identified**
If you examine the intervals generated by close cropping, you can see that the shapes are interesting and varied in dimension.

**keep these additional points in mind**

- Do you want a formal or informal view of your sitter?
- What will be in the background and how much of it will be included?
- How will the figure relate to the format? Will the cropping be close?

**Too symmetrical**

The human body is bilaterally symmetrical. In this example, the sitter is placed right on the vertical centerline, a violation of the **ONE RULE OF COMPOSITION**. Notice how the dull composition is divided into three nearly equal vertical sections.

**Divided in half**

In this example, the head is now in a sweet spot, but the composition is divided in half vertically, also violating the **ONE RULE OF COMPOSITION**.

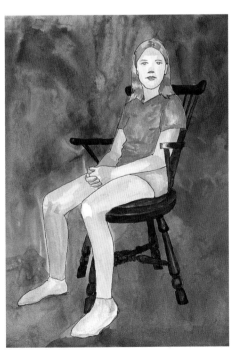

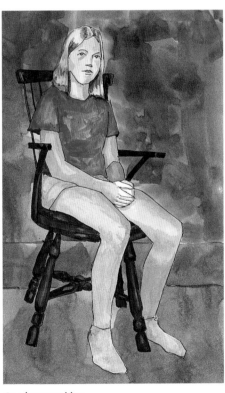

**Awkward composition**

Avoid tangents. Tangents often direct the eye out of the composition.

**Good composition**

Place the subject in a relationship that generates an interesting variety of shapes and intervals.

**Good composition**

A useful compositional device to keep in mind for portraiture is balancing an *active* side with an *inactive* side. The left side of this painting has less visual energy because it is strongly vertical. On the right, there is greater complexity and energy.

# plan a path for the eye

One main center of interest, a secondary focal point and two minor focal points are all arranged in a circle. The boy's face is the viewer's main center of interest, but his center of interest is his own painting. His gaze directs you to his artwork, which because of color and contrast is a powerful eye magnet. His brush and paint box also act as pointers to the boy's painting. The boy's hands are the other two focal points. The four points (face, painting and hands) keep your attention circulating through, but not out of the composition.

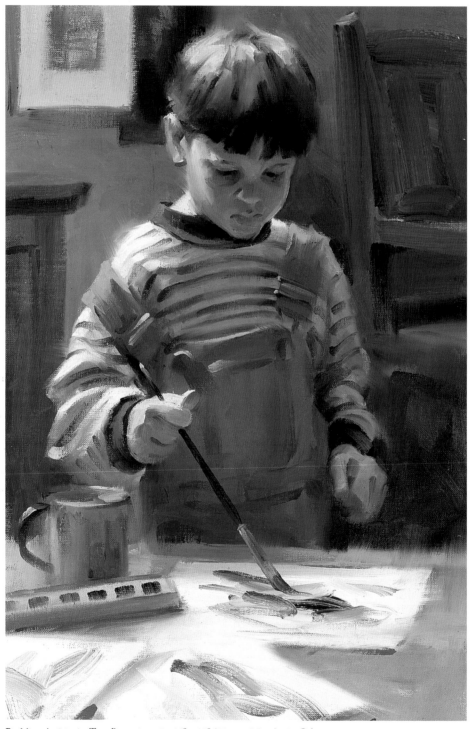

**Budding Artist** ✳ Tom Browning ✳ 16" x 10" (41cm x 25cm) ✳ Oil on canvas

# establish a mood

The head and shoulders of the silhouetted figure below are located in a sweet spot; several horizontal lines in the picture direct your eye there. The figure is alone, but not isolated; the mood is one of quiet and calm.

**The Seasons** ⁑ Dee Knott, AWS ⁑ 20" x 28" (51cm x 71cm) ⁑ Watercolor on paper

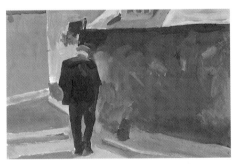

**Moving the figure changes the feeling**
If the composition were reversed, as for a mirror image, the eye would encounter the figure before scanning the rest of the picture, as if hurried; the effect would be one of greater restlessness. The figure would appear to be going counter to the habitual path of the eye, creating some tension. Psychologically, the right has more "weight" or importance than the left; therefore a figure on the right moving in that direction seems more comfortable.

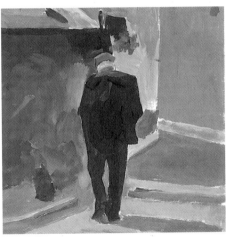

**A centered figure is boring**
If the figure appeared in the center, there would be little or no tension. Instead of calm, the composition would induce boredom.

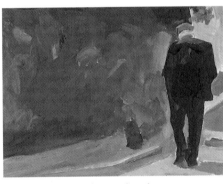

**A figure placed too close to the edge**
If placed too far to the right, close to the edge, the figure would appear literally and psychologically on edge. Since it appears to be moving to the right, the figure now directs attention out of the picture.

# creating a dynamic figure

The human body is an appealing challenge for artists and is their most enduring subject. It exhibits a marvelous agility, articulation and expression. In particular, the body has a dynamic balance that makes it a perfect subject for artistic composition.

The body is bilaterally symmetrical. The right side mirrors the left from head to toe, making the body naturally balanced. However, the potential for movement is so strongly suggested in its form that even when the body is static, it appears dynamic.

**Static**
When the weight of the body is supported evenly on both legs, the body is in static balance. Notice how the divisions suggested by the body's inner frame are parallel.

**Dynamic**
When the body shifts weight to one leg, the classic *contrapposto* position, the body is in dynamic balance. The divisions suggested by the body's inner frame are no longer parallel. This pose complies with the **ONE RULE OF COMPOSITION:** *Never make any two intervals the same* and is more interesting.

**Dynamic shapes radiate energy**
These shapes suggest a definite mood. They are dynamic and generate visual interest. The left and right sides of the body vary considerably even though the body itself is symmetrical in design.

# the figure as an interesting shape

Think of the figure as a shape. What makes any shape more interesting applies to the figure as well. Don't let colors and surface details make you unaware of the overall shape of the figure.

Look at the figure as an abstract shape. Does the figure fit into one of the boring shapes: a circle, square, or equilateral triangle? Does its shape have a vertical, horizontal or oblique thrust? Does it have "innies and outies" that give it interesting complexity?

**A triangle shape is static**

**A square shape is static**

**A figure with a diagonal thrust is dynamic**

**A figure shape with "innies and outies" is interesting**

# cropping the figure

Cropping presents a great opportunity for increasing the energy in a composition, so it should be done with thought and deliberation. All too often, cropping is almost accidental because the figure "just didn't fit" when it was drawn on the paper or canvas.

## cropping the figure

- Consider cropping the figure with one edge only.
- Be careful when cropping with two opposite edges—top and bottom or right and left—because it may look awkward or artificial.
- Don't crop the figure at joints, which suggests amputation.
- Crop boldly, but be mindful of all the shapes created, both positive and negative.

**Crop and float**
The figure can be cropped by one of the edges or several. One successful formula is called *crop and float* (by Bert Dodson in *Keys to Drawing*, North Light Books, 1985). If you crop at the top edge, don't crop at the bottom edge—let the figure float.

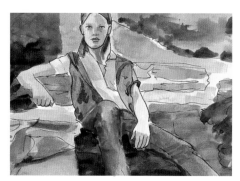
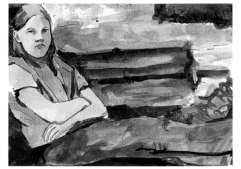

**Avoid artificial cropping**
It's difficult to crop effectively with opposite edges only. The result often calls too much attention to the cropping and looks artificial.

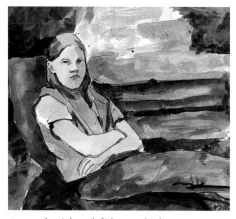
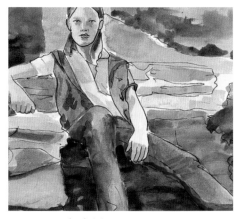

**Crop at the right or left, but not both**
When the figure is cropped on opposite sides it looks trapped; it cannot "float."

**Don't crop at body joints**
These "amputations" direct attention outside the picture.

### Cropping can help direct the eye

Not showing the bottom of the figure keeps attention focused on the face and the window, both are natural centers of interest. Value contrast makes them strong focal points as well. The urn in the lower left forms a secondary focal point that keeps the eye circulating inside the composition.

**Dawn of a New Day** ❋ Tom Browning ❋ 24" x 16" (61cm x 41cm) ❋ Oil on canvas

# cropping a portrait

There are two considerations when cropping a portrait. First, the cropping should be appropriate for the subject matter and should support what you are trying to communicate about your sitter. For example, a portrait of a public figure meant for public display might include the torso and the trappings of the subject's duties or office. A portrait of a family member meant for display in the home might be a more intimate close-up.

Good design is the second consideration for cropping. Regardless of whether you show the full figure, the head and shoulders, or an extreme closeup, the cropping should create interesting shapes, maintain a single focal point that is also the center of interest, and have dynamic balance.

**Create intimacy with the subject**
Cropping in close and eliminating most of the background produces a much more intimate approach. The closer you crop, the more intense an encounter the viewer will have with your subject. An extreme closeup of a face could be intimidating or uncomfortably confrontational.

**Provide a setting for the subject**
Cropping to include most of the sitter and some of the background is an opportunity to reveal more information about the subject and create the desired atmosphere—while generating interesting shapes.

**Focus on the whole figure**
A looser cropping provides fewer dynamic shapes; the figure here forms a strong shape on an oblique axis.

# value patterns

As in all compositions, the values in a portrait are vital to success. The principle consideration is making the face the focal point as well as the center of interest. Through contrast, the values in a portrait should help establish the face and head as the strongest eye magnet.

The greatest value contrast should be concentrated around the head and face so the viewer's attention is attracted and retained. If there is another area in the picture with strong value contrast (or sharp detail, bright color or busy patterns), a competing focal point will be created. The viewer's attention will be divided between the face as center of interest and a rival focal point.

A classic strategy often employed to create this value contrast around the head and face is to make the background dark behind the illuminated side of the head, and make the background light behind the shadow side of the head.

**evaluate the value patterns**

## in your portraits

- Does one value dominate, or are the lights and darks too balanced?
- Do the light and dark shapes vary in size, shape and distance?
- Do the lights and darks in the background work well with the lights and darks in the subject?
- Does your painting make use of the formula: *Mostly, some and a bit?*

**Strong value contrasts direct the eye**
This sketch is a great example of playing light against dark. The face is contrasted with a dark background, and the back of the head is contrasted against light. The strongest area of contrast is along the contour of the face, making it both the focal point and the center of interest.

**Phil** ✳ Ned Meuller ✳ 16" x 13" (41cm x 33cm) ✳ Conté crayon on paper

**Mostly, some and a bit**
Apply the *Mostly, some and a bit* formula to this portrait. The strong value pattern of this painting makes it irresistible. The pattern forms a pleasing configuration as a purely abstract design. Notice how the frames and the tie direct your eye to the picture's center of interest, the subject's smiling face.

**Terry Tollefson** ✳ Tom Browning ✳ 24" x 30" (61cm x 76cm) ✳ Oil on canvas

# group portraits

The **ONE RULE OF COMPOSITION**: *Never make any two intervals the same* can readily be applied when there is more than one subject, as in a double or group portrait.

### Double portrait

In a double portrait, it's more interesting if the heads are not equally spaced or on the same level—both violations of our **One Rule**. The relative heights of the heads may imply prominence of one over another, so be mindful of that significance to your sitters.

Watch for the direction the sitters are looking. If they are looking in different directions, or if one or both are looking out away from the center, a distracting pull out of the picture can be created.

### Group portrait

In group portraits, usually family groupings, keep in mind the principles of placement derived from the **ONE RULE OF COMPOSITION**. Do not allow the heads and faces to line up, be equidistant or form a boring configuration like a regular triangle or square. The heads should be at different levels and distances. Think of how boring it would be if all the heads were lined up equally on Mount Rushmore.

If you are painting a portrait of an entire family, make all the sitters look in more or less the same direction, or all of the them looking in toward the center. If one or more of the figures is looking out of the picture, it attracts the viewer's attention out of the frame.

**Boring**
Don't line up two (or more) faces at equal distances or along any central axis.

**Better**
In a double portrait, place one head at a different level and different angle for greater interest.

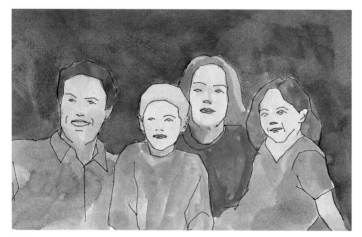

**Boring**
The heads are all at the same level. The lack of variety in their placement engenders a lack of interest.

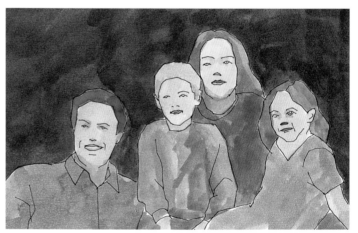

**Better**
The heads are dynamically arranged with eye-pleasing variety.

# multiple figures

To maximize eye-pleasing variation, groups of figures should be arranged according to the **ONE RULE OF COMPOSITION:** *Never make any two intervals the same.*

By changing the size of the figures, and the spacing between them, you can create varying intervals that work to create interest in your painting.

**Even spacing is boring**
Equally spaced figures of the same height are boring and look unnatural.

**Varied spacing is better**
Unequally spaced figures are more appealing and suggest more interesting social dynamics.

**Ground level placement is unexciting**
Unequally spaced figures of different heights and eye levels is more interesting, but the ground level is parallel to the bottom edge.

**Asymmetry suggests tension**
The eye and mind group proximate figures together. The three figures on the left form a unit; the figure on the right is isolated. This arrangement is not only attractive to the eye, but interesting to the mind because it suggests some sort of social tension.

**Scale variation creates depth**
Varying the scale of figures creates spatial depth and increases interest. Note that all the figures share the same eye level, which coincides with the horizon line and eye level of the viewer.

**Variety creates visual energy**
When figures in a scene are at different heights, sizes, eye levels and distances, the visual energy is maximized.

# figure interaction

When there is more than one figure in a painting, some kind of relationship is implied, and the viewer will attempt to determine what that relationship is, even if the relationship is one of mutual alienation. Where the figures are placed in the composition will give clues to that relationship. If they are placed close together, a stronger relationship is suggested; if apart, a weaker relationship is suggested. If the figures are symmetrically balanced or in the center, a stable relationship is implied.

Two figures facing each other will be interpreted very differently from two figures standing back to back. The viewer's eye will track the paths of contact. If figures are in physical contact, the point of contact will be a center of interest. If the figures are in eye contact, the viewer will follow the link.

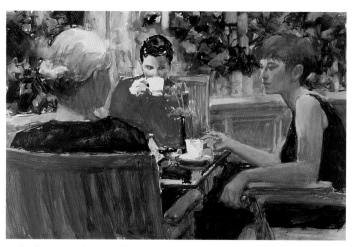

**Make the connection visually**
The figures are linked in a three-way connection. Looking over the shoulder is a voyeuristic vantage point that is hard for the viewer to resist.

**Three Women at Lunch** ❋ Arne Westermann ❋ 21" x 29" (53cm x 74cm) ❋ Watercolor on paper

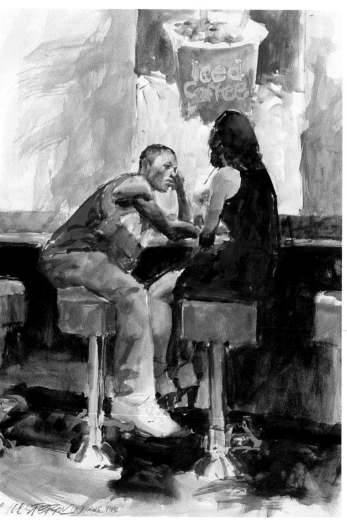

**Contact in the center of interest**
This painting is about the interaction between two figures. The faces and arms—the points of contact—form the center of interest. These figures are linked visually and mentally by the viewer.

**Iced Coffee** ❋ Arne Westermann ❋ 29" x 21" (74cm x 53cm) ❋ Watercolor on paper

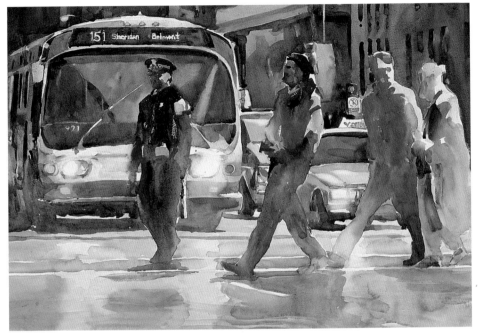

### A figure in motion

Uneven spacing of the figures makes this scene look natural. The scene appears like a moment frozen in time and convincingly conveys the bustling activity of a real street corner. Notice that the figure shown in motion attracts your attention.

**Struttin'** ※ Tom Francesconi ※ 19" x 27" (48cm x 69cm) ※ Watercolor on paper

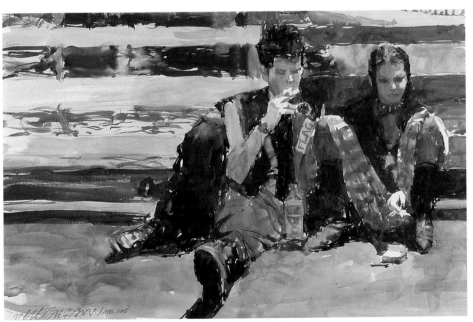

### Placement implies relationship

In this penetrating painting by Arne Westerman, the two figures are close enough together to be considered as a single shape, and as such this shape is located off-center, in one of the sweet spots. In fact, the figures are almost uncomfortably off to the side. This discomfort is increased by the very lack of interaction between the two youths. They both appear to be absorbed in their own worlds, not in direct communication. They are perhaps physically close but psychologically isolated, and it is this implied relationship that is the source of the painting's power.

**Boardwalk, Santa Cruz** ※ Arne Westerman ※ 19" x 29" (48cm x 73cm) ※ Watercolor on paper

# conclusion

The goal of this book is to make pictorial composition simple to understand, remember and apply. The principal concept of this book, expressed in the **ONE RULE OF COMPOSITION**: *Never make any two intervals the same* was derived from my experience teaching. I was frustrated by my attempts to describe how principles of design (unity, variety, harmony, contrast) were applied to the elements of composition (line, shape, color).

The theory was just too complicated. The fact that *I* could never remember all the principles and elements without a written list was a clue that it was not practical. The students were frustrated because the theories seemed better suited to analyzing what went wrong after the painting was finished than for avoiding mistakes while painting.

I no longer remember when I first summed up composition in one sentence, but the **ONE RULE OF COMPOSITION** has successfully simplified both teaching and learning how to make a better composition immediately. The **Rule of Thirds** and the *Mostly, some and a bit* formula are both corollaries of the **ONE RULE OF COMPOSITION**. My experience has shown me that these three concepts are the most useful to painters standing in front of a fresh canvas or watercolor sheet who want to get the composition right from the start.

I encourage you to post the **ONE RULE OF COMPOSITION** in a prominent position in your studio. Once you begin finding ways to apply it to all intervals—not just to spacing and dimension, but to balance, tones on a value scale, and colors on the color wheel—you will discover how widely applicable the **ONE RULE** truly is.

If, after reading this book, all you remember is the seven words—*Never make any two intervals the same* or even just the **Rule of Thirds** or the *Mostly, some and a bit* formula—this book will have met its purpose and I will have achieved my goal.

*never*

*make any two intervals*

*the same*